out of the darkness

OUT OF THE
DARKNESS

*A story of a CSI officers journey with murder,
love and compassion.*

DONNA M JACONI

LIBERTY HILL PUBLISHING

Liberty Hill Publishing
2301 Lucien Way #415
Maitland, FL 32751
407.339.4217
www.libertyhillpublishing.com

Due to the changing nature of the Internet, if there
are any web addresses, links, or URLs included
in this manuscript, these may have been altered
and may no longer be accessible. The views and
opinions shared in this book belong solely to the
author and do not necessarily reflect those of
the publisher. The publisher therefore disclaims
responsibility for the views or opinions expressed
within the work.

Paperback ISBN-13: 978-1-6628-5463-7
Ebook ISBN-13: 978-1-6628-5464-4

Out into the darkness –
Life, Love and Murder

Introduction

*I*n 2018 I had a severe injury to my right
ankle and leg. I had surgery and was
recuperating at my sister's house for sev-
eral months. I have never been one to
sit still for very long and I couldn't drive,
so I decided I would start writing about
a real look into the life of a Crime Scene
Investigator. In my 22 years of being in CSI,
and several other years as a patrol officer,
I have seen the unthinkable. Philadelphia's
Crime Scene Unit is very elite. I was one of
only a few women out of 45 officers. As
you read this book, you will see how I had

to prove myself as a woman over and over. From the most graphic mass murders to the heart wrenching things people do to each other. Yet none of this compares to processing the murder of a fellow officer. You are emotional, angry and scared. This takes highest priority in law enforcement. This is not because an officer's life is more valued than a civilian. If a Police Officer is murdered the entire law and order community is affected. You murder the institution which keeps all our country safe.

This book is a true story and a look into the day-to-day reality of police work. This, unlike any other job, takes you from zero to a hundred within minutes. Like having a cup of coffee then getting a call about a triple homicide. There's no time to finish your coffee, you gather your gear and run out. I personally want to thank all the fellow officers and their families for putting their lives on the line every day. Officers must endure the gut-wrenching screams of a mother on the sidewalk as

her son lies in the street shot to death, or speak with the family members of a fallen officer at the hospital. Most of the time an officer will know the fallen officer personally, but you must maintain your professionalism and do the job. After tough days on the job, officers must go home to their families and try not to break down. Cops must maintain a sense of humor as a defensive shield or they won't make it on the street. After reading this book you will see that the television shows are nothing like real CSI in Philadelphia, but you will also laugh out loud at some of the more lighthearted stories I have included. I hope you enjoy.

My most memorable crime scenes that will remain with me forever.

Midnight to 8:00 am tour was always terribly busy. We say nothing good happens after midnight, of course. It was about 4:00 am and the phone rings in the

unit. It was a quiet night until that call. There is a triple homicide in a house in north Philadelphia, and the doer (the bad guy) had barricaded himself in the house. I was assigned as the lead investigator. Two other crime scene investigators go along with me, as well as the Sergeant. That was everyone we had working that night. You see, in Philadelphia the work force is so shorthanded that on any given night there is usually only 3 or 4 investigators working each tour. This is for the entire city of Philadelphia, which includes approximately 2.5 million people. Over worked is an understatement. My weeks for nearly twenty-two years consisted of work and court. And when I worked midnights to 8:00 am, court was an everyday occurrence. So, after we finished our shift, we had to go to court and sometimes stay all day waiting to testify. It was grueling. I am not complaining because I loved my job, but I want to give you a clear picture of what my work days were like. Anyway,

back to the triple homicide. We arrived on the scene at about 5:15 am, and since it was April, it was still dark out. As we find the incident commander, we were informed that the doer will not come out until it is light out. He says he does not want to get shot by the police in the dark. Swat and hostage negotiation teams are there in addition to many news stations and the high-ranking Philadelphia Police Department (PPD).

Finally, the doer surrenders as day light hits. He climbs out the front window and swat takes him into custody without incident. He is a 38-year-old black male whose brother lives at the residence. It was now time for our team to go in and process the scene. Search warrant in hand, we put on our Tyvek suits and masks, gloves, and shoe covers. From the information we were provided, we were prepared for an extremely bloody scene.

As we proceeded into the front door, there were several gunshot holes in the

door and what appeared to be flesh. We walked into the living room and found a dead male on the floor in the most unusual position I have ever seen. He was literally lying under an end table face up. Well, what would have been his face. His face and head were completely blown away. Several shot gun shells were scattered throughout the room. Blood spatter covered the wall in the living room. I turned to my left and found another male face down in a small dining room with his intestines hanging out. He was shot in the back and in the head. This room looked like something out of the movie, *Helter Skelter* but ten times worse. I had been doing scenes for many years, but this was the most graphic scene I had been on. The white walls and refrigerator were covered with blood spatter. There wasn't a space anywhere that wasn't touched with blood. A 12-gauge shot gun will do that. I then turned to my right to head towards the kitchen, and I saw feet. A

young female in her 20's was lying face down. She was shot in the back trying to get out the back door to the yard. After more investigation on her, we discovered she was five months pregnant. Now it was a quadruple homicide. Later, we would discover the male in the living room was the doer's brother and it was a fight over drugs and gambling. One male made it out while the shooting was happening. He ran out towards the front door but took a shot to his arm and lost his arm. That was the flesh we saw coming into the house. The shotgun was bought at a hunting store, and it was the dead brother's gun, unfortunately. This one has stayed with me for many years. How do you go home and not have nightmares people ask? I do have nightmares!

Girl in duffle bag.

One of the toughest cases, like any that involved children, was an 8-year-old girl.

She was living with her foster mother and her foster mother's boyfriend. The young girl was reported missing by her foster mother, who said the girl did not come home from school. Any missing child of tender age (under 10 years old) is taking extremely seriously and all the manpower the city has is called in. Special victims, child abuse section, is the lead detective division that is assigned. They investigate, starting with interviews with school faculty, friends, and neighbors. Something was not adding up and we were called to the house to investigate for blood and/or any signs of foul play. We arrived at the south Philadelphia house and started with the child's room. Spraying a chemical called luminol. Luminol is a chemical that reacts to hemoglobin if it's present, even when cleaned up with bleach and not visible to the naked eye. You darken the room and if blood was present it would glow. There was no reaction in the child's room or the bathroom. We then

moved toward the mother's bedroom and just outside in the hall seemed to be some discoloration. We sprayed the wall in the hallway, and it lights up like a Christmas tree. There was a significant amount of blood. After conferring with special victims' detectives, they spoke to the foster mom, and she confessed. The child woke up for school and went into the foster mother's bedroom without knocking. The foster mother was with another man, not the man she was living with. The kid got scared and ran out. The foster mother ran after her, grabbed her, and slammed her against the wall in the hallway repeatedly. She did not want her boyfriend to find out she was cheating on him, so she killed the girl. She then duct taped the girl's body and shoved her into a large duffle bag. Her and the new boyfriend drove to the Schuylkill River bridge in west Philadelphia. She drove to the middle of the bridge, threw the bag over, then returned home and reported

the child missing. Our next assignment was to go the bridge and meet the marine unit. Luckily, the river was low, and with the boats out we found the child within thirty minutes. Like any recovered body, we had to video tape the recovery. Myself, my partner, and the division detective, Mary, one of my best friends, were there. We had to climb down the rocks on a very slippery slope with a large video camera in hand and my crime scene kit, while trying not to fall into the river. We located the bag and took some pictures of the outside of the bag and its location. I bent down to unzip the bag and my partner was video-taping. Just as I got the bag mostly open, a large snapper turtle jumped out and I fell backward. It scared the crap out of me! The turtle was chewing on the girl's leg. She was taped with her legs and arms together, looking so frail. The next day we returned to the house for more pictures and to cut the wall out for evidence. The boyfriend who lived there was all upset

and near tears. I thought to myself, well at least he had some feelings for the child. But later he said he was upset about the wall. He had just painted it and he wanted to know who was going to pay for it. Unbelievable!! Where were the protests against the system who failed this little girl? Protests against this despicable woman and boyfriend? They received only a ten year sentence each for taking that child's life. That was not justice for that child.

2008-2009 Homicide of Police Officers

The Philadelphia police department had seven officers killed in the line of duty. All were heart breaking murders. The one than stands out the most was one of our Sergeants working in downtown Port Richmond section of the city. In broad daylight on a beautiful Saturday morning, a robbery alarm goes off at 9:55 am at a bank branch inside a local supermarket.

Three people dressed in Muslim women's garb walked into the bank, pulled out a handgun, and robbed the bank. They then left the bank in a blue van that was double parked in front of the store. 911 was called, and the bank manager gave a description. The dispatcher gave the information over radio, which is called "flashed information." This is instant information so officers can start looking for the perpetrators. The Sergeant hears the flash information and starts to head toward the bank. He was only a short distance away when he turned down a side street and spotted what he thought was the van. He notified police radio and turned on his lights and sirens. He was behind the van, approximately 10 feet away, when suddenly the males jump out. The Sergeant has his door open, and they blast him with an AK47. The driver's door was hit creating a giant hole and the Sergeant's vest was pierced. That part was told by neighbors who were out

sweeping their sidewalks and were horrified by what they saw. One woman even had the gun pointed at her and luckily the perpetrator's gun jammed. By the grace of God, the women survived. The van fled the scene and the neighbors rushed to the Sergeant's aid. One of the neighbors was in the military and they got on the radio and conveyed "officer down," the highest priority of calls. A woman holds the Sergeant's head as he passes away, not wanting the Sergeant to die alone.

In the meantime, scores of police wagons, cars, motorcycles, and the air tac team (our helicopter unit) swarm the area. Unknown to the bank robbers, the bank had put what they call a "Blood Hound" in a stack of money. This is a GPS tracking system that looks like a credit card. This way when the bank gets robbed, the bank can activate it like a tracking system on a car. One of the males had already been caught at the scene, and two remained in the van. Myself and my partner happened

to be on the street coming from another scene. We headed over with lights and sirens on and joined the chase. Police radio activated the Blood Hound and was able to give us turn by turn directions for the perpetrators' location. We spotted the caravan of police vehicles. Everyone wanted these guys because they murdered one of our own. My heart was racing scared, but we wanted to be the ones to get these guys. Finally, the van pulls over and the radio screams out. There was a sea of police cars lined up and officers jumped out and ran towards the van. We were the third car behind the van, guns drawn. A K9 officer was the first car, and a female officer was second to the van. As we just about get to the rear of the van, the door slides open and out comes a guy with the AK47. He points it at the K9 officer, and the officer was smart enough to grab the barrel of the gun and push back. The guy shot himself in the head. The other male took off

running but was apprehended in minutes. It was over and they were caught. One male deceased and two arrested. How do you process this and do your job after you witness a fellow officer get gunned down? You dig down deep and fight back the tears and the fears.

The second part of my job was to prosecute the defendants. We prepare for months on enormous trials like this. We had over 125 pieces of evidence collected from three different scenes. The bank, the shooting of the Sergeant, and the shooting of the male perpetrator. We had three mannequins donated from a local chain store. We dressed them in the Muslim garb we collected from the scene. They were so lifelike that the bank manager screamed when she walked into the courtroom. I testified for 3 hours on the stand. Usually it is approximately one hour, but we collected so much evidence and this was a death penalty case. People waited for an hour before the trial to get

a seat in the courtroom. I was nervous, yes I was. The last thing you want to do is mess up testimony on such an important trial. As always, my fellow officers were there for support and when I got off the stand and finished, everyone said I did a great job, including the deceased officer's family. I felt like crying because there was so much stress and sadness. Both defendants received a death sentence. A victory in court, but it would never bring back our brother in blue. After that trial, the Assistant District Attorney took us all out for drinks.

Rape and Murder

A case that will never leave my memory. In 2010, I was working shift work at that time and happened to be on daywork, 7:00 am to 3:00 pm. It was a beautiful sunny Saturday morning, and unusually quiet for the first half. Our office was the forensic science building.

We received a call came from Police Radio that a female body was found in a vacant lot. The section of the city happened to be only a two-minute ride from our office. The scene was explained to us over the phone. A woman was walking her dog early in the morning and stumbled upon the deceased women. She was savagely beaten and nude from the waste up. The woman who found the body didn't have a cellphone with her, so she had to run home to call the police. She then jogged back to the scene and waited with the deceased woman until the police arrived. After we spoke to her, she said that she went back because she knew the deceased woman was someone's daughter and didn't want to leave her alone. As tears rolled down her face, I really admired her for that statement. I was the assigned lead CSI on this case. When we arrived, the scene was taped off as usual. We walked up and saw the deceased woman and the horrific scene,

as it was clear that she was severely beaten. We observed items scattered all over the vacant lot, including a purse and makeup. A women's bike was thrown on the sidewalk. We were processing the scene for hours. The usual crowd and news cameras were there all day. We tried to shield the body from the news cameras without contaminating it. At one point, a neighbor around the corner called me over to the crime scene tape and said that he found a white T-shirt in his yard. His dog had it. We ran over to collect it. This would be a key piece of evidence used to put the animal who did this away. His DNA, along with the victim's DNA, were found on the shirt. A great job of piecing together video up and down the street helped identify the defendant. After a year, the trial began as you can imagine. Listening to the ugly details of your loved one's last moments can be agonizing. I have always made it a habit of when I am testifying to use the victim's

name over and over. Such as "Cindy's shirt" or "Suzy's hair." To me, it shows the jury the victim was a person not just a body. At the end of my testimony, the victim's mother hugged me and thanked me for using her daughter's name. I had done my job. While I was testifying in this case, I noticed the forewoman on the jury. She was crying most of the time and when we were showing the very graphic photos, she shed even more tears. It was hard for anyone to see those photos. In the weeks before this trial I had hurt my foot and needed surgery. I told my surgeon I couldn't proceed until the trial was over. The last day of the trial, when the defendant was found guilty and given life without parole plus 80 years, I called my doctor and said OK, when is the surgery?

In the next few days, I had to get to the hospital for pre-surgical testing. Exhausted, I made it for the next week. I arrived, checked in, and sat down to read the newspaper. Not paying attention to

anyone really, I hear my name called and I kind of just walk toward the voice. You see, I was dreading this because I hate needles. Ever since I was a child, I would faint anytime I even saw a needle. I could see anyone else's blood and guts, just not mine. Ironically, when I got to the nurse who called my name I looked up and the nurse's face was bright red, and she burst out in tears. It was the woman who was the forewoman on the jury who was crying when I was testifying. I did not make the connection until she screamed OMG it's you, the crime scene officer! She hugged me and told me what a great justice I did for the victim and her family, and how she admired my courage. She called over several nurses and with great pride said, "This is the officer I was telling you about." She took me in and could not have been gentler and kinder to me. She even came the next day to the outpatient surgical floor and wished me good luck and stayed with me. She said she believed the

homicide victim was watching over me and sent her to do the same. The surgery went well. I guess there really are angels.

Stairway to evidence...

In 2016, a south Philadelphia row house was the scene of a young woman who was shot to death. This area was a very solid, what I call, Italian old school neighborhood. But it was becoming somewhat "yuppy." We got the call around midnight to respond. I was up as the assistant, not the lead on this one. We arrived at the scene and asked what preliminary information the first officer on the scene had. Usually, its considerably basic information since the scene is in its infancy. Believe me, by the end of the night it changes, always changes. I have learned that what appears to be is usually never what it is. The main thing about processing scenes in homicides is to let the evidence lead you, you don't

lead the evidence. The deceased was a white female, 28 years old, lying on the bedroom floor, shot. The homicide medical examiner arrived shortly after us. The house was a two story 3-bedroom home. I was the assistant, so my responsibility was to sketch the entire house and then measure and collect evidence. I was halfway through the sketch of the lower level, which consisted of the living room, dining room, and kitchen. I was leaning my foot on the first landing step of the staircase to the second floor. As I am laying out the sketch, Homicide Det. Marchino has gathered some car keys with remotes, trying to find the dead woman's car. We don't leave anything unturned. The car may have evidence. Det. Marchino is standing at the door outside, clicking away with these different remotes. Suddenly, as I am leaning on the step, the stairs open in the middle. If you have ever seen the show, The Munster's, and the pet dragon would come up from

the stairs, this was exactly like that, minus the dragon. This was the evidence that would lead us to the reason the victim was shot. The stairs were built on hydraulics. It was a very sophisticated system. I start stomping my foot trying to figure out what triggered the opening, but nothing. Just then, detective Marchino walks back in and he has the remotes in his hand. We all yell at once, "Oh my god the remotes!" Yes, as he was clicking them on the front porch, one of them controlled the stairs. Drugs, money, and guns were recovered from under the stairs. Mystery solved.

Spider on the loose

We received a call about a person who was killed at a party in the Roxborough part of the city. It's a suburban residential area in which a lot of officers and firemen live. City workers are required to live in the confines of Philadelphia, so they would move to the tips of the city.

We arrived at the scene and the patrol officer was standing outside the property securing the scene as he should. We rolled up and spoke to him as usual, giving our names and badge numbers to him for the crime scene log. Usually, the first officer on the scene will start the log, this is to document everyone who is on the scene. The officer only had preliminary information, as it was early in the investigation. However, he did say to us, "Be very careful as the victim's pet tarantula is somewhere loose in the house." "UMMM, a TARANULA as in big black hairy spider?" I replied. "Yes, but they did trap the Boa Snake," he said. So, I said to my partner for that job, Lincoln, who was a very big officer (6'6 and 260 LBS), "Ok, you are handling the pet if we come across it." As the lead investigator on this job, I was responsible for taking pictures and finding the evidence. So, I am gingerly looking through the house for the evidence, particularly ballistics, as the

person was shot several times. Someone mentions the trash can in the kitchen was knocked over in the melee. I go over and lift the can and pull out a paper towel covering some trash. I screamed at the top of my lungs like a 3-year-old. I had found the giant black hairy tarantula. It was alive and well. The can went flying and my partner came running. We trapped it with a Tupperware bowl and finished the scene. Yes, a few nights of spider nightmares for me.

Raccoon falling.

Whenever a police officer discharges their weapon off or on duty, the Crime Scene Unit must respond and investigate. This is in conjunction with Internal Affairs, the Homicide Unit, and Detective division. One early morning around 6:00 am we responded to a home in northeast Philadelphia. It was a detective's home where she lived with her spouse

and kids. Apparently, roof damage from a past storm was not repaired, and racoons were living in the space between the roof and the ceiling of the master bedroom. Around 3:00 am a loud crash was heard in the dark of the night and the officer grabbed her gun and shot. A very large raccoon fell on the opposite side of the room. It scared the crap out of everyone in the home. The roof was repaired immediately after that.

My signature saying for the last thirty years has been, "SO, I met a woman."

Chapter 1

I was never alone in my life up until I was 58 years old. I grew up in Philadelphia, Pennsylvania. Specifically, South Philadelphia. Our neighborhood was called the Italian Market area. We lived on Federal Street, which was only a 2-minute walk to the Italian market. Now when I say market, it was not an indoor store like Target or Walmart. No, this market was outdoors mostly. The streets were filled with fruit stands, meat stands, clothing, fish and live chickens, and men yelling the special of the day "5 oranges for 50 cents!" And in the street, behind the wooden fruit stands, were barrels of fire. The smoke could be smelled for

blocks. You knew you were close by when you smelled the smoke. The fires were to keep warm on those cold days. You see, the market was 12 months a year, 7 days a week. Oh, and yes, the Rocky movie in the 1990's was filmed on the streets of south Philadelphia. That movie put our neighborhood on the map. In later years it was very sheik to go there and shop and experience the Italian family togetherness. Small kids helped with the fruit stands. The businesses were handed down from generation to generation. It was a tradition we were immensely proud of. Our other claim to fame was cheese steaks. Some incredibly famous places have been the topic of much dispute. Gino's or Pat's steaks? Anyone from Philadelphia knows that question. You see, these outside steak places are across from each other and at any time of the day or night there is a line at both places. People from all over come to test each place and see which is better. The big

question when you get up to the window is Wit or Wit out? Cheese that is. I favor Pat's steaks myself.

Chapter 2

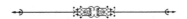

My family included my mother, four brothers, and two sisters. My twin sister and I were the youngest kids. We were always told we had it the easiest of all the kids. My father in his day was very handsome and apparently a lady's man. He was from New York and my mother grew up in an affluent Philadelphia family. My mother came from an exceptionally large family also, with six brothers and five sisters.

Unfortunately, I never knew my grandparents as they died before I was born. My mother was 100% Italian and from a large tight knit family. I suppose was my mother was very smitten by my

father, Joseph. Some of her family members have called my mother the black sheep of her family, as she married out of her class, so to speak. My mother was the strongest, funniest, and kindness women I have ever known. She was always my inspiration in everything. We are much alike, and I often catch myself seeing her in me. Such as my milk phobia. She used to go around saying to us kids, "Smell this, does this smell fresh?"

What would my mother have thought about what is going on in the world today? Growing up, we cared about our neighbors and our neighborhood. I often look up and ask for her guidance. I believe this is where I get my head strong ability to weather a lot of the storms I have been through. As a kid, we grew up extremely poor. Let's say white privilege didn't apply to us. My ancestors came over on Ellis Island, as they were immigrants from Italy, poor and starting from scratch. As a family, we did everything

we could to make enough money to put food on the table. We did not sell drugs or go rob a grocery store. We sold soft pretzels and paper shopping bags on the streets of the Market. I was once telling this to one of my friends, Sally, who grew up in the suburbs, and she asked me how many pretzels came in a shopping bag. I laughed hysterically and replied, "No. We sold soft pretzels and shopping bags separately." We would go early morning to the market and yell, "FRESH PRETZELS! SHOPPING BAGS!" We all had our way of helping out. My siblings and I were always very close and to this day we are all still extremely close.

Chapter 3

My brothers often tell the story about how our mother used to make things like decorated soaps with flowers on them and ribbon. She used Camay soap and straight pins with ribbon. They would go door to door selling them, hoping to make a few dollars. They were 12 or 13 years old at that time. They had to grow up quickly and never complained, they just did it.

My oldest Brother, Brock, would tell me how he worked for a guy, Nate, in a tailor shop at the age of 14. He said it was so hot some days that he would nearly faint. He would have to walk to deliver and pick-up laundry for 8 hours. My other

brother, Pete, would tell me how he and Jack, my second to oldest brother, would sell water ice for this Italian ice stand. They would work all day and the guy, Gino, would count the cups, not the water ice amount, so if they were short, they did not get paid for the day. It happened all too often that they didn't get paid, so my mom started giving them dixie sweetheart cups and they made their own profits. That is the school of hard knocks lesson. I would come home from school to my mom making a giant pot of pasta Fagioli, basically just beans and small pasta noodles. It cost her $1.00 to make and would feed us dinner for the night. Eight people and leftovers, now that is a cheap meal. Today in a nice restaurant you would pay at least ten dollars per person for the same.

Chapter 4

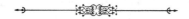

As for my father, Joseph Sr., he never was a part of my life. He married my mother in early 1940 when they were living in Hazelton, Pennsylvania. He was tall, dark, and handsome. He was very Italian, and I am sure most thought extremely attractive. They moved to South Philadelphia after a few years and lived with my mother's family for a while until my oldest brother, Brock, was born in 1945. Brock has always been the father figure of the family. He was the oldest and he took on much responsibility at a young age. He worked a full-time job and supported the family. Then they moved to a ridiculously small house in the heart

of the Italian market neighborhood. I remember those days when people were so friendly you could leave your doors open and neighbors would watch each other's kids and feed each other's kids. They would look out for each other. There were no muggings or robberies, and if there were, you had to answer to the neighbors. It was pretty much street justice. Crime in our area was exceptionally low. Myself and my siblings, we would have never thought to steal or vandalize anything because we had our mother to answer to, not the law. She was strict with our curfews and chores, and it made us all better adults.

My brother Jack, who is my second to oldest brother, is much like me. He has a great sense of humor, loves movies and music, and oh yes, Barbara Streisand. One Halloween, when I was about 6 or 7, I was playing in front of the house one afternoon, and a large dog came out of nowhere. I had always been afraid of

dogs for some reason, and I got spooked and ran. I ran right into an oncoming bike. I broke my leg in three places. It was two days before Halloween. When I was in the hospital I started crying and my brother jack asked if it hurt that bad. I told him that wasn't why I was crying. I was crying because I thought I would miss Halloween because I would have a cast on. That night, Jack made me a white boot to match my cast. I was a baton Twirler and he carried me door to door. We made the front page of the local newspaper. I will always cherish those memories.

Chapter 5

From what I've been told, my father was in the military for a few years. When he returned, my brother, Pete, and my sister, Patti, were born. My parents moved into a little bigger home in the same neighborhood. My mother worked for a few years before my brother, Bob, was born, which then made five kids. My mom decided to stay home to take care of the kids. My father was not home most of the time. In fact, my siblings say they don't remember a time when we ever sat down for a meal with him. He worked construction for a while, then some dry cleaners, but in 1959 he got a fairly good job with the city of Philadelphia License

and Inspection Department. Life should have been good for our family, but it was not. My father had a secret life which we did not find out about until later. I remember when I was about ten years old and went to a friend's house for dinner. I said, "Wow! You have a mom and a dad." I had not realized that a family was supposed to be comprised of both a mom and a dad.

Chapter 6

When the topic of my father comes up, my siblings would tell me that my mother would make excuses for my him about why he did not come home to us some nights. She would say that he was busy with other things. Apparently, these other things were other kids and a full-time girlfriend. By the end of 1958, there were four other children with other women whom my father had been with. All remarkably close in ages to my brothers and sister. My father left my mother with the five kids and went to live with this other woman. He didn't seem to care much about how our mother was getting by. She could not work and

watch my brothers and sisters. For about six months our family struggled until my father finally decided to return. My mother wanted to make the marriage work, so she did everything she could to reconcile. In those times it was shameful to be divorced. She took him back with open arms. 1958 was also the year my twin sister and I were born. My mother had no idea she was having twins. She went to the hospital in labor and gave birth to me 11:30 pm. The nurse said baby girl, 6lb 8oz, beautiful and healthy. My mom was delighted that she had a sister for her first daughter, Patty. They wheeled her into the recovery room, but my mother was still in pain, extreme pain. So back she went into the delivery room, and 37 minutes after midnight, she had another girl, my twin sister, Dana, 6lb 2 oz. My mother now had seven children all under the age of 12 and a husband that was too busy to be there for the delivery. No surprise there. All my life I

told the story about how me and my twin sister were born on different days. When someone asked when my birthday was, I would say 29th/30th.

Chapter 7

Six months after the July birth of twins, my father packed his bags and left us. This time never to return. This was the beginning of our family's strength and determination. We vowed that family would always come first. It has always been my strength to know I have them to turn to. We spent the next ten years of our childhood living in a three-bedroom house. One bedroom was for the three girls, one was for the four boys, and the third was my mother's, of course. Only one bathroom with a tub; no shower. We did have assigned bath times at night. School, homework, and then baths started at 6:00 pm and went until 8:00

pm. Never miss your time or you went to the end of the line, which meant no hot water. It was a test of our faith in each other and mom. She was the rock of the family. I never saw her cry, but I am sure she did. Only now do I understand the strength she needed. These hardships and my mother's perseverance shaped our future relationships. I met Ron, my ex-husband, when I was seventeen. I had to quit school, as most of us in the family did, to go to work and help support the family. My very first job was at a Photo Mat booth. If you don't know what that is, let me explain. I worked in a 6'x 6' booth with just a telephone in it. On the corner of 8th and Chestnut in the center of the city of Philadelphia. It was a terribly busy corner. People would bring their film to me, I would take their information, stick the film and their information in a Photo envelope, and the same night a truck would come by and pick it up to send to the laboratory. Five days later (yes five

days) they would drop the developed photo's off to me and I would call the customer to pick them up. Yes, it took that long to see little Danny's birthday or someone's wedding pictures. And yes, I looked at most of them. There were some very interesting pictures, that is all I will say. Well, I did that for a year and not much chance for promotion, so I started looking for another job.

Chapter 8

I started working at the South Philadelphia branch of Roy Rodgers Restaurant when I was just eighteen years old. I was hired by the manager and ironically his name was Roy. He was a nice guy, but very business oriented and kind of strict, well for a seventeen-year-old he was. My first day on the job I went in with jeans and a cute shirt. All ninety-eight pounds of me. Roy called me in the office and said, "I think you are a small top and shirt?" He handed me a crisp new uniform. To my horror it was a plaid red and white cowboy looking skirt, a white peasant looking lace blouse, and a bright red cowboy hat to top off the outfit. I

was a Roy Rodger cashier and member of the team. I handed out little cards to the kid's saying they were in the Buckaroo Club and yes, you guessed it, had to say, "Howdy partner may I serve you?" A must greeting at Roy Rodgers. That phrase has never left my brain even after all these years. I was constantly getting yelled at by the manager, Roy, about my hat. Either I wasn't wearing it, or had it pushed back looking like Bonnie and Clyde. I should have known in my later years when I became a cop, I would hate wearing a hat.

Ron was a few years older than me when we met, he had started working at Roy Rodgers a few months after me as an assistant manager. At first, we did not like each other.. Ron was a good-looking guy, very Italian, and funny. He had a serious side also. We began to work the same shift, mainly closing time. Then, as young people do, we started socializing with our co-workers. Ron, I, and few of our co-workers would go bowling and

to the movies. At that time, the drinking age was eighteen and I had just turned that age. It was the first time I felt independent. Living at home with my mother being extremely strict, I still had to be home at 10:30 pm. We would work and then hang out in the parking lot. Most of the time we just talked. Eventually, after few months were dating. We were inseparable and started talking about marriage. On September 9, 1978, we had a huge wedding with about 200 guests. We had six bridesmaids and six groomsmen. My brother, Brock, walked me down the aisle and gave me away. I did not want my father to be invited because he was never there for me like my oldest brother had always been. After a few glasses of champagne, Brock sat in the yard and cried. Only one of two times I have ever seen him cry. He was our Rocky Balboa. He was the strength of our family, and I will always cherish him and his wife who continue to be the strength of our family.

Chapter 9

We had saved for the wedding scrimping and pinching pennies as much as possible. Our parents were not able to pay for it and we were determined to have the wedding we deserved. We had 12 people in our bridle party and 200 guests. It was a very traditional Italian wedding. Looking back on it now, I think I was in love with the idea of a wedding and a place of our own, and not really marriage or Ron. We rented a cute one-bedroom apartment in south Philadelphia. We lived just across the street from the local movie theater. My best friend, Patsy, worked there so I got to see movies for free all the time. I saw *The Way We Were*

with Barbara Streisand approximately 44 times. I have been and still am a long-time fan of her movies and songs. Our apartment was suitable until a year and half after we were married. I became pregnant. We were elated and so were our families. As usual, I couldn't wait to call my mom and tell her. One of the things I miss to this day is being able to call my mom.

House hunting was a new experience for us. We were looking for something that would be suitable for a young couple and a baby. We looked for several months and finally found the perfect house. It was on a street in south Philadelphia with lots of families. It had three bedrooms, a nice little yard, and it was two blocks from the schools. It was our dream house, and it was perfect. We bought it for $55,000. Everyone we knew, including our friends and family, were only minutes away. We had lots of people come over to help us paint and clean every chance we could. Pizza and beers were their payment every

weekend. It was finally ready for our baby boy. On March 4, 1980, he came in the middle of the night, of course. My water broke and I woke up in a daze. I was only twenty years old and scared to death. I started shaking my husband trying to wake him and I dialed the phone to call my mom and sister to ask them to meet us at the hospital. Our beagle, Mindy, named after the TV show *Mork and Mindy,* had to be fed first and I had to take a quick shower. Although we were only five minutes from the hospital, it took us about one hour to get there. When we walked in, I heard my mother yelling that I had to be there because I had called her an hour ago. That was my mom, she was loud and voiced her opinion.

Chapter 10

Our son, RJ, arrived at 8:08 am. An 8-pound baby boy. Ron cried when he saw him for the first time. Both of our families waited to hear it was a boy. It was a joyful day for all. I wanted pizza and a milkshake, and I had earned it. RJ was an adorable baby who smiled all the time. He wasn't a baby that cried much. We were a happy busy young couple. I returned to work after six weeks because we could not afford to live on just one income. At that time, I worked as a pharmacy technician at a busy local pharmacy with a crazy pharmacist named Joe Valentia. He was always on the phone yelling at his wife and kids. Always had issues with

the customers. It began to get incredibly stressful because dealing with people's medications was serious business. I wanted a better job. Even though this one was a step up from Roy Rodgers, I guess, I still wanted something better. I had no education because I had dropped out of school in 10th grade, so I decided to get my diploma (GED). I told Ron I wanted to go to night school two nights a week. He agreed and wished me luck. So, I enrolled at South Philadelphia High. It was a great experience, and I met some cool people. One person I met there was a woman named Gigi and she was my age. We hung out together a lot and I clicked with her immediately. Now that I look back, I believe she was Gay. I had never known anyone who was gay. Well not that I knew of at that time. The fact that we clicked so well should have been a clue, I guess.

I passed the test for my diploma with a 96 on the first try. GIGI and I both did, so we celebrated with an Italian dinner

together and a bottle of wine. It was an extortionary night. When I went home, Ron and RJ had a sign in the window saying, "Congratulations!" It was a perfect ending to the day. I was a high school graduate. It seemed so important to me because I had done what I set out to do. I knew I could do anything If I set my mind to it. In the next few years, I tried different jobs. I was only 23 and had a 3-year-old but I knew I had to find a career. A career I would enjoy and that also made good money. I worked at an eye glass and contact lens center for a while and made a few good friends there. My twin sister had finished high school and went on to college. She was the first one of our family at that time to graduate. We were all so proud of her. She was a business major, so she got a part time job at Strawbridge and Clothier working for the buyers and computers. In 1985, I moved on to Strawbridge and Clothier. After following my sister's suggestion, I submitted

an application, and I got a job in the computer department where my sister was a manager. Our department was responsible for keeping inventory of the stores on the computers. It was a great job with benefits and lots of fun people to work with. It changed my life in many ways.

Chapter 11

MJ and I met at work when I was asked to train her on the inventory system. She was a full-time college student studying drama and music. I was a bit reluctant when my boss asked me to be her training sponsor. I worked 8:30 am to 5:00 pm, Monday through Friday. MJ worked 1:00 pm to 9:00 pm, five days a week during the school year. I thought I would be ok with just being with her a few hours a day. She walked into the office on her first day and as I was being introduced to her, I was thinking she was adorable and sexy at the same time. She wore all black. She was all of 5' tall, about 100 pounds, blond hair, and blue eyes. No

one had ever caught my eye like this. It was the strangest feeling, but I liked it and was immediately intrigued by her and the feelings I had.

Chapter 12

Strawbridge & Clothier coworkers were like family. The company was a retail store with clothing and furniture. It was one of the best stores Philadelphia had. The co-workers all went out on Fridays because it was payday. After work we would go to the local tavern for a drink or two. We had great Christmas parties and dressed up for Halloween in the office. MJ fit right in. She had the best sense of humor and the sweetest laugh. We immediately became close friends. I was training her on the computer system, and she caught on very quickly. I spent many hours close to her. My afternoons were spent with her at work and when it

was time for me to leave, I wanted to stay. I left from work and thought about her all night. I could not figure out why though. Soon, I made excuses to stay late after work and eventually I started to drive her home. She lived about 35 minutes from me on the opposite side of the city, but I hated the idea of her taking the train after dark. We laughed and joked all the way home and sometimes we stopped for a bite to eat. I talked about RJ and Ron, and she spoke of her boyfriend who was a mechanic and how they usually just ate takeout food, smoked pot, and had sex. Not much of a relationship I thought. But I was envious of him none the less.

Chapter 13

Patsy was my best friend since grade school, and she was a bridesmaid in my wedding. We met when I was 12 years old, and we immediately became best friends. I was over her house constantly and her mom was like my second mom. We told each other everything and we double dated a lot. Patsy was beautiful, tall and thin, dark long hair, and a smile that would kill you. She knew in high school that she wanted to be a hairdresser. She worked part time at the movie theater until she finished beauty school. The movie theater was our favorite hangout at 16 years old. I would get in for free and help her out behind the candy counter

and I got to watch the movies. I already told you about my record number of times seeing *The Way We Were* and that Barbara Streisand is my favorite. Those things wouldn't be true if I hadn't been such good friends with Patsy. Patsy eventually opened her own shop and did very well for herself. One night, I went to the shop to get my haircut and while sitting in the chair and just making small talk I somehow found the nerve to blurt out to Patsy about MJ. It went something like this, "Soooo I met this woman, well not a woman she is 21 and a college student, and well I think I am in love with her and I want to be with her." I was shaking as I said it. This was 1985 and I had no idea what I was feeling. Patsy immediately put down her scissors and slapped me in the back of the head and said "Are you nuts? That would make you a Leslie!" We Laughed hysterically. Patsy had my back, and she knew I was serious. From that day on she called me Leslie. Lesbian....we

never even knew the word back then and
to say it out loud to someone was a mir-
acle for me.

Chapter 14

I felt some relief saying how I felt out loud even though I was scared to death. MJ was not a lesbian, nor was I, but we were incredibly close. She would leave me notes in my desk and I would rush in and go right to my desk before I even got my coffee. My face would light up and it made my day. The notes sometimes would say, "Wine and cheese party tonight at 6pm you and I" or they would say something from Madonna, as we both loved her. *Desperately seeking Susan*, the movie with Madonna, was just premiering and she would leave me notes saying, "Desperately seeking Donna meet me for lunch." I didn't get it

at first but then I realized she was flirting. This friendship went on for months like this. We started doing things with RJ like going to the Zoo and to the movies on the weekends. Ron was not demanding or jealous. As far as he thought it was just a friendship, which it was. It never crossed the line except I was madly in love with her, unlike anything I had ever imagined. I didn't know what to do. How do I tell her how I feel and risk our friendship? If her signals weren't what I thought, they were it could be a disaster.

Chapter 15

MJ's college degree was especially important to her. She often invited me to come see her perform in a play. She performed lots of Shakespearean roles like Othello and Desdemona. I often helped her rehearse her lines. It was amazing seeing her perform as she loved it and was particularly good. Temple University in Philadelphia was a good college, but it was in a not so good neighborhood, so I usually would drive her to rehearsals and pick her up. Muggings were not uncommon there and I worried about her. She wanted to be an actress, but the competition was hard, and she needed that extra edge.

There was one day at work, I remember it like it was yesterday. It was Christmas time and MJ was on break from school, so she was working days. I found a note in my desk saying, "Meet me in the café for lunch, I want to tell you something." I hurried to the cafeteria, and we sat down to eat. She said, "I have some news, I have been accepted to study abroad in London Arts program, it's a great honor." She said this as there were tears in her eyes. I said, "Wow that is great, when do you go?" "January to July," she replied. There was complete silence, I could not speak. "Six months you will be gone?" I asked. She shook her head yes. I felt like someone cut my heart out. As happy as I was for her, I was devasted for us. I did not know how I could make six months without her. I know she was thinking the same thing. Neither of us could eat and we sat in silence the rest of the time.

Chapter 16

We had a really good Christmas that year and MJ and I were able to spend time with each other Christmas night, after RJ was asleep and Ron was full of a big dinner. We met and exchanged presents and planned to take a ride to the beach on the weekend. It was so cold, but we didn't care. Saturday came and we drove to Ocean city, New Jersey and walked along the beach, laughing, and playing around. It was the last time I would see her for six months because she was leaving on Monday. I came so close to telling her how I felt but something inside of me told me not to. We hugged for a long time, and I knew what I had to

do. MJ gave me a bracelet and I gave her a diary and an autograph book. She promised to get autographs of Madonna or boy George or both. She promised to write to me and send me her address when she arrived. No cell phones, of course, and no internet. Just snail mail and land lines. It would be painful waiting for her to return.

Chapter 17

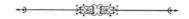

On the day after MJ left for London, I asked Ron for a divorce. He was shocked! What had I done he said? Was I crazy he said? WHY he keeps asking. He was a good father and a good husband, but I knew I had to be single if I had any chance of being with MJ. Not that I knew what was going to happen, but I knew how much I loved her, and I couldn't be married anymore. I uprooted my whole life in the hopes she felt the same way. My family was shocked of course. They liked Ron, somewhat. He was a noticeably quiet and unassuming kind of man. My mother kept asking why? , Was he hitting me or did he cheat? I said no, I just

want to be single. That song by Madonna, *Crazy For You*, described how I felt about MJ but I couldn't tell anyone. I was petrified of anyone finding out. Ron was in disbelief and of course my son who was only five at the time was so confused. I know now I was selfish to leave, but I couldn't stay with someone I didn't really love. It was the worst six months of my life, yet I knew it was what I had to do. My emotions were all over the place. At that time, being gay was just not something you admitted. It was the scariest step I had ever taken.

Chapter 18

The house that Ron and I lived in was in both our names, which was a problem because cause when I told Ron I wanted a divorce he refused to move out saying it was his home and was not leaving. So, I worked and saved and put money down on a small apartment in northeast Philadelphia where I knew no one at all. Except, that's where MJ lived with her mom before she went to London. I took my son and half the furniture and moved. I was alone in a strange part of the city. I had to write MJ and give her my new phone number and told her to call me on certain nights so I knew I would be home to get the call. She called and said,

"What is up, why the new number?" I said very calmly, I left Ron and got an apartment in NE Philly. She responded, "Ok, when I get home, I will help fix it up real nice." Not even a why or what happened.

Meanwhile I would get lost every time I left the apartment. Coming from the south Philly Italian area and moving to this other part of the city was strange. I once went to the deli section of the grocery store and asked for a pound of cream cheese. The clerk looks puzzled and said, "That is what you put on bagels?" "No," I said, "It is what you eat with Bologna AND CHEESE." There was a completely different lingo. I felt a bit lost but there was only three months until MJ came home. I knew I could make it. RJ was in first grade, and I was keeping busy working. I was dreaming of a life in love with MJ, not knowing who she would be when she returned. And there still was her boyfriend. What would happen there?

Chapter 19

Homecoming day was finally here, and MJ was being picked up by her boyfriend around 5:00 pm at the Philadelphia Airport. I thought I would die knowing she was home and having to wait until the next day to see her. I didn't have to wait because she came to my apartment as soon as she got home. Saying she had to see where we are going to hang out now. MJ was glowing and she had matured incredibly. She was more beautiful than ever. Her eyes met mine as she hugged RJ. She gave me the same hug but longer and harder. We missed each other immensely. The next few weeks were hectic, and MJ was over my

apartment helping get me organized. RJ went with his dad on the weekends, and it wasn't a good situation. It was very tense between Ron and me. Most weekends MJ and I would do things together. One beautiful Saturday morning in June, MJ said, "Let's go to the SPCA and get a kitten for you and RJ." She loved animals and especially cats. I could never say no to her, so we went and as it happens, they had a brother and sister eight weeks old. We named the boy, who was black, Romeo, and the girl, who was a beautiful multi-color petite kitty, we named Juliet. We were still just friends, but she vowed to share the responsibility in taking care of the new kittens. It felt as if we were forming a family together.

Chapter 20

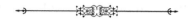

We came home with the two kittens and all the supplies that go with them. We set the litter box in the bathroom, and I hoped for the best. I had never had animals growing up, so this was all foreign to me. Madonna's new movie, *Desperately Seeking Susan*, was premiering that night. It was a chilly rainy night and we decided to go to the theater, so we got tickets in advance. When we arrived at the theater, we got our popcorn and drinks and found our seats. After about ten minutes the movie started. MJ leaned over and asked in a quiet adorable whisper, "Did you put the toilet seat down?" I had this puzzled look

on my face, and she said, "The kittens might fall in. I shrugged my shoulders because I wasn't sure. After a few minutes I grabbed MJ's hand and said, "Let's go." It was now pouring rain outside. After we ran to the car and ran up the steps to the apartment, we were drenched. I could hardly get the key in the door. I was so worried about the kittens but thank God they were asleep huddled together on my "new" sofa. What a relief as we stood there dripping wet. MJ looked at me with those big beautiful green eyes, leaned in, and kissed me romantically on the lips. She said, "I knew you loved me when you said let's go," and I knew I loved you. That night was the beginning of the most honest and romantic relationship I ever had. As we made love it felt so natural and right. From the first kiss I realized what it was to have true love. To give yourself to someone without hesitation. Never did I feel that with my husband.

Our relationship lasted six years. In the 80's when being gay was taboo, families didn't understand. We eventually went our separate ways but we remain friends to this day. She was the love of my life. Always has been. We worked together and lived together. Our co-workers eventually found out and were delighted for us. We had a few women that were in our division that came out to us. We eventually started to do things with other gay couples, and it was great. At first we felt alone, but then we started seeing other gay women. Our first experience at a gay women's bar was amazing. Seeing hundreds of women just like us and feeling comfortable to hold each other's hand and slow dance was a monumental freedom, and it had a new meaning for me. I vowed to never go back into the closet. Love was Love.

Chapter 21

While MJ and I lived together in the northeast area of Philadelphia, we both started playing sports. MJ played ice hockey and I played softball and flag football. We started to meet friends who were gay also and we started to feel more comfortable with ourselves and being who we were. I met a few women who were talking about taking the Philadelphia Police test coming up soon. The ladies were on my team and would eventually become some of my best friends. In 1988, several of us applied for the written test. You got notified by mail if you met the criteria and were given a place and time to show up for the test. Some of us received

the same date and time to take the test at a local high school. Back then, there was no book to study with or online research to use, you just took the test. I am not sure if I was more worried about doing well so I wouldn't be embarrassed to my friends or more worried I would do well? The test came easy for me, and I passed with a score of 89. A month or so later, a few friends and I were going through the background investigation, polygraph, etc. Soon, it was time for the physical and that would be the last part. If you passed the physical, you were in. I didn't think I would have any issues. The place we had to go to for the physical was called City Medical at Fairmount. I had an appointment but was the most disorganized medical facility I had ever seen. Years after I became a cop, I realized this place was a cop's worse enemy. The workers seemed to resent most cops and especially white cops. Time and time again, co-workers

would relay horror stories of this place,
yet nothing has changed in 25 years.

Chapter 22

My appointment was at 9:30 am, so I got there twenty minutes early. I signed in and it was crowded as usual. In my 29 years of being a cop I was only IOD (injured on duty) twice, and this is the place you must go to before you can return to work. They are very unorganized and rude.

Everyone dreads going there, but you don't have a choice. You suck up waiting three hours even when you have an appointment. I sat down next to a female named Kay, and she is there for the same thing, hoping to get into the next academy class. We chatted a bit and I found out she worked for the city as a

prison guard and wanted to transfer to PPD. She was braver than me. Being a prison guard was an incredibly stressful job. I could see why she would want to transfer. Little did I know how stressful being a cop would be. We say our good-byes and I finally got called in. They did a brief exam and then asked about my eyes. At that time, I wore contact lenses. My vision was 20/20 with my lenses. The technician instructs me to remove the lenses and read the chart. Of course, I struggle a bit as I am near sighted. She tells me I failed, and I can appeal. That's it. No other explanation. I was pretty dev-asted and got in my car and bawled my eyes out. I drove to my mom's house in south Philly and told her what had hap-pened and cried. She said she was scared for me to be a cop and maybe this was a sign. Things happen for a reason she reminded me. I didn't want to accept that, but it was a fact. I was rejected. I found out later that week, all my friends got in

and were going to be in the upcoming academy class. It felt like it was the lowest point of my life. I had a great job . They treated me like family. I was basically the only non-Jewish person working there. I interviewed for the job, they immediately liked me. They were great people. They always asked about RJ all the time, they let me bring him in on Saturdays when I didn't have a babysitter.

Chapter 23

A few days after my failed eye test, I got a call in the evening when I was at home from a Lieutenant G. He identified himself as commanding officer of the Identification Unit of the Philadelphia Police Department. He said he saw my name come across his desk as someone who passed all the tests, except the eye test. He asked if I was interested in a civilian job with the PPD in the Fingerprint unit, and would I like to come in for an interview? I had no idea what they did, but I said sure. I went in the next day and was hired on the spot. The Lieutenant was impressed. He said that he did not want to take a chance and let another

department scoop me up. I said I had to give two weeks' notice to my current job. He advised me that I would be in a six-month training class, and it was 4:00 pm to midnight. I now had to find a babysitter and only had two weeks to find one. On March 1, 1989, I started training to be a Fingerprint Technician. Little did I know that what my mother had said about everything happens for a reason, would be the best advice ever.

Chapter 24

The first night of class we had to get fingerprinted and photographed for our security ID's. Our main instructor, Kathy, had taught at the FBI for years and eventually moved to Philly and worked for the City of Philadelphia, he was a character, and if she liked you that was good, but if she did not, oh boy look out! I got on her good side, and we became somewhat friends. Our class consisted of myself, Sheri, Wanda, Theresa, Lee, Cal, Rayo's, and Mike. A diverse group of people who had to work as a team for the next six months. Well, we dropped to seven quickly after Theresa left. After the first few days, we all thought she was kind

60

of strange. She wore her skirt backwards most nights. Anyway, during a lunch break one night, she was going through her handbag, pulled out a large bag of marijuana, and our jaws all dropped. She was gone the next night. Unbelievable! It was an incident that I thought to myself, this must be a set up to see if our integrity was ethical. I never did find out if it was or was not. That was the beginning of my trust no one attitude. This is something police officers must have to survive. They must be on guard 24/7 on or off duty. The public doesn't realize that when you become a cop, you transform into this person who one minute will be sitting in your patrol car drinking a coffee, and the next minute you respond to a shooting, and you may have someone's brains poured out in front of you. Your adrenaline goes from 0 to 100 in seconds. You must think and decide things in the blink of an eye. If you don't, you or someone else may die. It's not like Joe

Blow working as a mechanic and deciding if he should use a new or used muffler on Mrs. Smith's car. No, you have someone running up on you screaming that her baby has been shot and you yourself have a two-year-old son at home. That kid will die if you don't do CPR correctly. The CPR class every year that the PPD gives you, and you always hope that you will remember, two breaths and 15 compressions, or is it 15 breathes and 2 compressions? You're scared and excited, but you can't show it. Someone you don't know is counting on you to save their child's life.

Chapter 25

Back to 1989, and the grueling six months of training with written test after test. As a Fingerprint Technician there would be times when we would have to go to the medical examiner's office and fingerprint a deceased body. It could be a homicide victim or an unknown person. So, we all were going for a day of training on Friday. Thursday night I did not sleep a wink because I was so nervous. My saving grace was my BFF, Dr. Laurie. She was a surgeon and did a six-week internship at the Philly Morgue. She talked me off the ledge and calmed my nerves. She was, and still is, my best friend and wing woman as we always say.

As intelligent as she is, sometimes she will call me for advice, and often calls me Buddha, because I am the voice of reason for her.

Let me tell you a little bit about Dr. Laurie. She is an awesome doctor and the nicest woman and friend I have ever met. We met in 1990 and I must explain how we became best friends. After my breakup with MJ, I was pretty much lost. I had made friends from softball in north-east Philly, so I started socializing with them. I met a Philly cop at a game one night and we started dating. Her name was Dana. Dana was way different then MJ. she had dark hair, dark eyes, and was very quick witted and streetwise. She was a patrol officer in one of the roughest areas of the city. We hit it off well. It was not anywhere near what I had with MJ, but she was a good distraction. I thought we were exclusive as the months went on, at least I know I was. One day, Dana had been hurt at work and I went over to

bring her some food. After a few hours, I was ready to leave, and a young lady was approaching the door. I said hi and introduced myself. She told me her name was Laurie but added that she was Dana's girlfriend. As you can imagine, this came as a shock to me. After a brief conversation, we agreed to meet the next day for a drink. We exchanged stories over drinks and realized we had been seeing Dana at the same time for months.

We both broke up with her the next day, but like many things in my life something good came out of something negative. Laurie was in medical school and terribly busy, but somehow, we found time to hang out together. We supported each other through the good and bad stuff. Thirty plus years later and she is still my wing woman and best friend.

Chapter 26

When the federal government finally passed the Federal Disability Act in 1990, the Philadelphia Police Department was involved in a class action suit with about one hundred or so claimants. In January of 1993, I received a letter saying I was included in this suit due to rejection for my eyesight, as did hundreds of other applicants. We eventually won the right to go through the applicant process again. You see, Philadelphia's eye qualification was so high that we could have gotten into the FBI but not the Philadelphia Police Department. So, the process started over. I had the upper hand because I already had an employee

number and three and a half years as a technician. This would count in seniority if I became a sworn officer. I breezed through everything quickly and on March 1, 1993, I entered the Police Academy. Words like excited, scared, happy, and elated can't even describe how I felt. I was in a relationship with a woman Dina who was a supervisor in the PPD. Without her help and guidance, I would not have made it. The times I came home so tired from the PT and exhausted from the classwork and the laws and shooting at the range, she always reminded me what was at the end; I would be a Philadelphia Police Officer. Dina was my rock then, and still is a good friend and confidant. We can debate a topic, see each other's point, and then toast it with a beer.

The first person I saw as I parked my car the first day of the academy was Kate, who I had met at the medical facility last year. She also got rejected for her eyesight. All 102 recruits in my class #301

were eyesight rejections. We got the nick name, "The blind class." Kate and I sat next to each other in Platoon A because our names were alphabetically close. Platoon B were the second half of the alphabet. A and B were always in competition. Best marching, best shooting, highest grades, etc. On our second week in class, we were all called into the auditorium and the captain advised us that the city had cut recruits pay by $6,000 a year and we must sign off on it. Like we had a choice? The next day the news cameras were in the parking lot asking to interview us. I had a crappy car I had bought from an old lady just to get me around until after I graduated. So, me and my "opinion", and my 1969 Cornet were on TV. My other half was not happy, as a boss in the police department she always said don't bring attention to yourself. Ummmm I KNOW!!

Most of us quit our jobs and now we were being told we were making $28,900 to be a police officer. Three people quit

on the spot. I had a son, a car payment, rent, and everything else, but I was not going to let that stop me from becoming a police officer.

Chapter 27

I could tell a million funny and serious stories about the seven months I spent in the Academy. It was the best time you would ever spend in your career. You didn't just make friends, you made lifelines. The person sitting next to you or behind you might be the person on the street that has your back, the person who saves your life, or you may save theirs. It was truly always "no man left behind." It was not male or female, it was BLUE. If you made it through this training, you were then a part of the biggest brother and sisterhood in America. You were never alone. Being a police officer, you will be judged by not the color of your skin but color of your

uniform. You choose the uniform, the profession, and you choose to remove yourself from the civilian life. You walk into a party of a friend, and you are not introduced as Donna, you are introduced as Donna, the cop. Unlike the accountant or the store manager, your profession is always worn on your sleeve, like it or not. I asked people not to introduce me as a cop to people they didn't know because you could never know if they were cop haters. I once met a friend's brother and was introduced as a "cop," and he said he hated all cops and stared at me. I asked what he did, and he said a contractor. I responded and said damn, I hate contractors they are all scammers. He didn't get my point. Ironically, he served some time in jail for domestic abuse. You never know who you are speaking to.

July 29th/30th, my birthday and graduation day. It was a glorious day. My family and friends were at the graduation. My significant other was nervous about where

I was going to be assigned. We would not know until the hour before graduation. I hoped to be assigned with some of my closest classmates. Unfortunately, my mom didn't go to the graduation, but the rest of my family did. My mom was sick a lot and it would have been too risky. Graduation was at the Convention Center. 96 of us made it through the academy and 5 did not make it.

When I was called up to the stage and handed my badge, I could hardly breathe. Badge #2918; I will never forget that feeling. Let the celebration begin! It was short lived because we were to report for duty at 9:00 am Monday morning. We had a big party at our house for my birthday and graduation. I was 30 years old AND now a police officer. I kept repeating that in my head. When you want to be a cop you think you will go out and change the city, make it safe, and save lives. Saving the kids was the biggest goal I had. If I could just save one kid. I remember a

mom saying to her kids "If you don't be good the police officer will arrest you." And I would say NO, don't put that in their head and scare them about the police. Start them early by telling them that we are there to help them and keep them safe. If they get lost or hurt do, we really want them to be afraid of the police or do we want them to find a cop and say help me?

Chapter 28

I was assigned to the Center City District, a community-oriented station. I and 16 other classmates were assigned there. I was not happy because I wanted to be driving a car and chasing bad guys. However, I was going to be walking a beat and getting to know the businesses and community. I eventually grew to love it. I was assigned to CCD for 8 months and it was the best time. I walked about eight miles a day and was in the best shape of my life. Our Sergeant Orr said to us at orientation, "A good cop never gets cold or wet and never goes hungry and always back each other up, remember this and you will survive." He was so right. When it

rained we would be inside the local hospital? When we were hungry, we knew the best places to eat. When a radio call came out, we would run, not walk, to back someone up. Our first two weeks we spent with training officers riding in patrol cars. My first week I was with officer Joe R. He was a great cop with 14 years' experience. He treated me with respect and showed me how things were on the street. The first thing every rookie hears is, "Forget everything you learned in the academy" and, "This is the way it works on the street." Joe and I were on patrol on my fourth day, and it happened to be payday.

Joe said, "Hey, we can go to the bank and cash our paychecks if you want." This was before direct deposit. I said sure. It was just about 9:00 am and the bank should have been open. We got out and went to the door, Joe tried the door, but it was locked. He said, "Oh, too early," and we got back in the car and would come back in a little bit. As we drove away, not

two minutes later, the police radio went off, "Beeeepppp." There was a robbery in progress at the bank we were just at. Joe let out a bunch of profanities and screeched the tires. I wasn't sure what was happening. We got back to the bank and found out the employees were hand-cuffed and there were three men with shot guns running out the back door. Joe was beside himself because we should have realized it was few minutes after 9:00 am. We should have been thinking like cops. We could have been shot if we walked in on it. It scared me but even better yet, it was burned into my brain to always check before you walk into a store, bank, or wherever. Complacency can be deadly.

Chapter 29

Eight months went by quickly and we were kept extremely busy. I made a lot of "good" arrests. I received "Officer of the Month" several times and I was in the best shape of my life. Walking the beat about 8 miles a day wore out several pairs of shoes. My third week, I was walking by a Center City Street where there was a Fine shoe store. A sharp looking older male was standing outside and said, "Good morning officer." I still was not used to that name! His name was Earl and he said, "Officer, your feet will never last if you continue to wear those patent leather shoes." He sized me correctly in a minute and had me trying on

Rockford's. The most comfortable shoes ever! This made me feel like people genuinely cared and Earl became a good friend. Every year I would get my new shoes and tell stories of being a rookie.

My very first 5292 was in the summer on the third floor of an apartment building. 5292 was our code for a dead body. The Philadelphia Police would refer to it as a 5293, but it wasn't until I had been on the force for years that I came to know the way that code came about. In the 50's the extension of the morgue was 5292. Now a 5292 that has been deceased for more than a few hours or if the temperature is about 80 degrees outside can be your worst nightmare. The smell is like no other that you will ever smell. As a rookie, one of the senior officers suggested I put Vicks Vapor under my nose. It did not help much and as I got more seasoned, I started using some cologne instead. My theory is Vicks is designed to open the nasal passages, which is the opposite of

what you really want. My first 5292 was a young woman suicide. It was incredibly sad, and it burned the image into my head. I went home feeling overwhelmed and my significant other, who was a cop, said I would get used to it. You process it and push it down, but you never get used to it, not if you are a decent human being.

Chapter 30

What you get used to is figuring out a way to prepare your mind to tune out the ugly. Your defensive mode must protect you, protect you from the most unbelievable things that people do to each other.

Someone once said to me, "Being a cop is like having a front row seat to a three-ring circus." You never know what you will come across. The basic citizen cannot even imagine the graphic things we must see and endure. Let alone touch a bullet riddled human being taking his last breath in front of you while you're putting your hands on their chest to try and save them. I am not sure any of us

thought this is what we signed up for when we entered the Police Academy, but we do it. There is no such thing as "No" in my job description. The missing link that the public doesn't get is that some people, no matter white, black, latino, etc. can act inhuman and can shoot a grandmother for $20 or drive by and kill a five-year-old. We as officers, must adapt and deal with this ugly environment. We see this every day, every week, every month, every year. We as Police Officers are human and we then start to treat people who kill and maim as what they are, Monsters. Many officers go home and cannot share any part of their day because their family would not understand and could not imagine it. I was lucky to have a spouse who could understand because she was on the job also. Some others have been with were not so understanding. One of my ex's would be jealous of me when I took a mental health day off. Saying "oh you get so many sick days " I used to say

then join the Police academy and put your life on the line every day. And you would be intitled to take a mental health day!

Little did I know my destiny in the Philadelphia Police Department was to deal with the dead. Un 1994, I was transferred to the sixth district. Everyone that came to the Center City district had to go after eight months because a new academy class had graduated, and they would be taking over the walking beats. Finally, I would get a patrol car. The sixth district was a great learning district. It was partly business, restaurants, and bars, and part residential, which included Society Hill (million-dollar homes) and some low-income, high crime areas. I was happy to be in a real district. After a few months, I was partnered with Lisa Mahoney. She was a good cop and a fun, easy going person. The perfect match for me. We became good friends, and we were usually assigned to be the wagon crew (prisoners, dead bodies, etc.). #603

EPW. We had the best Sergeant who would get a kick out of the fact that our last names rhymed. He would say them together, Jaconi and Mahoney, no matter if we were together or not. One night we were patrolling near the City Hall building when we saw a brigade of black SUV's with lights and sirens running. We started to follow them thinking a big crime was in progress. Suddenly, over the police radio we hear, "Mahoney and Jaconi report asap." The Sergeant informed us that we were chasing the Mayor..LOL. To this day Lisa and I are still great friends

Chapter 31

Lisa and I made some great arrests and we always seemed to be in the right place at the right time. Once we were just cruising along and there was a minivan in front of us. Nothing unusually suspicious about it, except when they threw a body out the sliding door while moving! We went in pursuit of the van for a few blocks and then they bailed out in a wooded area. As we called for backup and started searching along the woods, it was dark. Thank God for my flashlight, the bad guy was lying in wait and grabbed my ankle to pull me down. Meet my flashlight dude.

Arrest made and the shooting victim survived. Lisa and I were a great team.

She was seeing a cop who was assigned to the district that crossed ours. He and my spouse were in the same district. We would stop in occasionally, and finally Lisa asked if I was with Dawn. I said yes, and I am glad you were brave enough to ask. She said she was so happy I had someone and that we will always be partners and got each other's back.

Chapter 32

My mom passed away July 2, 1994, one year after I graduated from the Police Academy. She didn't talk much about my job; I'm sure it was fear. When I graduated, she gave me a necklace with charm that had my badge number on it. I never took it off. I always thought of it as my protection. when I walked into the hospital, the nurse on duty said, "You are Yolanda's daughter, the cop?" I said yes, how did you know? She has your academy picture in her drawer and shows it to all of us. I knew she was proud of me and that was the best way she could show it. My mom had a tough life early on with raising all of us alone and I never

forgot that. Police are like family your second family. My mom was in a hospital that was in my district that I was assigned to. The last few days she lived I was lucky enough to spend time with her because I could visit and be on call at work. I miss her funny humor. I know she has always been looking down on us and is proud of all her children.

Chapter 33

The next few years were difficult in my personal life. Losing my mother was a huge blow and it took me a long time to get back to living life and having fun. Unfortunately, my relationship died in that time period. I began working the "gayborhood" in Center City, Philadelphia. It was fun and got to see what was happening in the gay community. In the meantime, my spouse had suggested I put a transfer into the Mobile Crime Unit (CSI). After all, I had the fingerprint experience and she had heard that a few officers were retiring from there. It would be a great unit to be in. It is considered one of the most elite units in the PPD. I said yes immediately and told

her I would type up my transfer request asap. Could I get in? It was a hard place to get into with perhaps only 30 officers. I only had three years' experience as a cop, and a total six years of city time. Breaking up with Dawn was totally my fault. She was determined to get promoted every few years. I honestly thought she would be the first female police commissioner of Philadelphia.

One night, while working a detail to the "gayborhood" in Center City, I met a woman and her few friends. They asked for directions, and I got out of my car and walked them a block to a little piano bar where their friend was performing. Two of the women were very talkative asking questions, but the third was incredibly quiet. They were obviously gay and figured out that I was. As I said goodbye, the third woman, Marcie, called me and said "Officer." I turned around and walked back. I knew that minute I should have just got back in my car! She said, "Would you

like to come back after work for a drink?"
She had big brown eyes and an adorable
smile. I said sure, and that began my affair
of six months. I fell in love with this free
spirited, artistic woman. She was unlike
anyone I had ever met. She called me
Officer all the time and it was adorable.
She viewed life as everything pure and
good. Something I needed at that time.
It didn't last though. Afterwards, Dina and
I broke up. As they say, "A person comes
into your life perhaps for a season and
perhaps for a reason."

Chapter 34

D awn and I split on good terms, and we were settling into a temporary apartment. I wanted to buy a house, but I just needed some time to look. I worked hard and had great support from family and friends. I dated a few women, but no one caught my eye. I even had a stalker. She was a cop who would show up on every arrest or stop I had. She would become a bit crazy when I started dating someone. It was a lesbian drama thing, and I did not do drama.

I was called for an interview with CSU in early October. I met with the commanding officer and two sergeants. I explained my qualifications and my

excitement to be in that unit. It seemed like it went well but I wasn't sure. Never did I think it would happen. The next day I was in the district operations room, which is where all the administrative cops sit doing endless amounts of paperwork. A certain Corporal, an old timer, said to me, "Kid, did you really put a transfer into the CSU? You are a female, and you only have three years on the job." I shrugged my shoulders and walked out thinking I had to get in.

Roll Call was a part of our daily routine, we stood with our squad in rows and the Sgt. or Lt. would check equipment and pat you on the back making sure you were wearing your ballistic vest. They read off any pertinent information for that night, including crime stats, etc. and they gave out assignments. I was called to the front of the room and Sgt. says, "Jaconi #602 wagon with Mahony." I say yes sir and he says, "This is your last night working the wagon." I am puzzled and he hands me

a memo. I was transferred to the Mobile Crime Detection Unit, and I was to report tomorrow at 9:00 am! He said, "Fucking A you did it!" Everyone applauded, and I fought back tears. I loved the cops I worked with, but this was a career move I would cherish. My first thought was to call my mom and tell her she was right when she said everything happens for a reason, but she had been gone for a few years and I still caught myself wanting to talk to her. If I hadn't been turned down for my eyesight, I would not have had the fingerprint training and I would have never gotten into that unit. I still miss her so much, but I talk to her when I feel lonely.

Chapter 35

I had a become good friends with Donna in the Police Academy when we met on her first day. She was in the class a few months behind mine. We had stayed friends and one day she called and said her, and her girlfriend were going out to shoot pool, and Betsy, her friend, was coming. She asked me if I would like to go. I said sure. I did like pool. We met at Donna's house and waited for Betsy to show up. Betsy called and said she was running late. She arrived about a half hour late and was apologizing saying she was getting her haircut and it ran late. She was quite cute, so I said, "I forgive you." We had a quick bite to eat at their house

and then decided to go to the bar where the pool table was. The bar was called Stanley's. It was a quaint little place close by. We arrived and got our beers and a fist full of quarters for the pool table. I loved playing pool and I had that in common with Betsy. She was a very skillful player. We had a great time laughing and playing competitively. The night ended around midnight. We didn't exchange numbers, but I knew she was as interested as I was. Being new in the Crime Scene Unit, I was focused on the training, and I needed to bring my A game in for the next two years. That is how long it would take until I was considered a senior CSI and could handle homicides, police discharge, or any other major crime.

Photography was a part of the job. Not just point and shooting, it was night-time photography and available light using a tripod. In the early 90's we used black and white film. We had to develop our own film by going into the dark room

and removing film from the canister and pull-out film. We had to cut them into negatives and then print the photos, hoping we did not expose the film accidently. All this was done in a dark room.

Chapter 36

When processing a crime scene, you only get one shot at it. There are no do overs. CSI gets there and we observe the scene immediately after the crime. The evidence must be measured and collected exactly where it is found. The photos should depict this. The big challenge is the onlookers. Most crimes are in the worst neighborhoods and if you get a hot summer night you might have 100 people out. It was not uncommon after the yellow crime scene tape is up and officers are securing the scene, that someone just lifts the tape and strolls right through the scene. When you try and stop them, they just say I am going

to the store or to my house. But didn't you see the tape? Oh yeah, I did. I started to say at one point, did you not see the OJ case? DNA evidence? and they would say, oh yeah.

Chapter 37

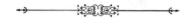

Mike was my first partner in the Crime Scene Unit. Mike had been shot years earlier in the line of duty. He survived but was transferred to the Crime Scene Unit. He was a fantastic cop and Crime Scene investigator, and he taught me so much. I could never tell him how much appreciated him. In 2001, Mike was off duty and was in downtown Philadelphia. It was Superbowl Sunday, and he was hit by a car while crossing the street at night. By the grace of God, a highway cop that knew Mike saw him and gave him CPR. He survived but was fighting for his life. Unfortunately, Mike was in a coma for a month, which was the

longest month I have gone through. He eventually came out of it, but not without some major permanent injuries. He was wheelchair restricted and extremely limited in his ability to speak. We speak a few times a month and he still called me his sister. Black and white partners, sister and brother in blue, I love him like a brother. Life goes on and I eventually got a new partner at work. I miss him everyday.

It was early November 1996, I was at my friend Donna's house again, and Donna and her girlfriend happened to mention that Betsy was in the hospital because she had back surgery. I said we should call her, so we did! Donna and her girlfriend spoke to her first and then I got on the phone. We chatted for about a half hour and finally she was getting tired and said I should call her at her mom's next week. She would be recovering there. She gave me the number and I said goodnight. I called her about a week later and we set up a day for lunch. I picked her up and we

went to New Hope, Pennsylvania, which is a small quaint town by the water with cafes and shops. She was in a huge back brace and a bit stiff, but she did not complain. We had a fantastic time. We went and ate lunch at a little place by the water and laughed and joked. After Lunch, I suggested maybe a ferry ride, so we did, and then we went to another place for some Brie and wine. She had an awesome laugh and smile, and not since MJ would someone melt my heart like she did so quickly.

Chapter 38

My new position in the police department, starting a new relationship, and raising a teenage son was for sure challenging. Thankfully, Betsy and RJ got along, and this was probably due to Betsy being ten years younger than me. They had a lot in common, big Philadelphia sports fans. Philadelphia Eagles especially. It was important that they got along because it was difficult enough that I left RJ's father, but now being with a woman. I have always felt guilty about this but as they say, it is what it is.

The crime scene unit was a shift work unit, and for the first six months I had to do all three shifts, which were, 7 am

to 3pm, 4 pm to 12 pm, and midnight to 8 am. It was hard on your body. You eat, sleep, and go to the bathroom differently. Eventually, the city realized that cops were constantly getting sick from this and changed it. Now you have a permanent midnight to 8 am shift and a rotating day and second shift. I opted for the rotation. I figured at least I had two weeks where I would be able to be home at night and have dinner and sleep normal. Unfortunately, a cop's life expectancy is exceptionally low with shift work and stress.

Chapter 39

My first homicide where I got to be the lead investigator happened to be a federal witness in a south Philly Italian neighborhood. It was probably a hit. It was an older gentleman who was leaving his house with his wife early in the morning to go testify in federal court. As he stepped out of the house a gunman shot him in the head, leaving the wife without a scratch. It was a quick clean homicide. He used a revolver, so no bullet casings were left behind. When we arrived at the scene, yellow tape was securing it, and there were lots of news cameras. Oh yes, the news was usually there before us. We check ourselves and make sure to have

our hats on. My partner, Mike, turns to me and says, "This is going to be your first money shot my sister." I didn't understand what he was saying but I went ahead and found the homicide detective to get the briefing. Blood, a hat, and a wooden cane was all that was on the sidewalk. We did our photographs and measurements and got ready to collect our evidence. As I went to pick up the cane covered in blood and bag it, the cameras were clicking and clicking. The next day I was on the front page of all three newspapers, the money shot indeed.

Chapter 40

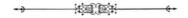

My relationship with Betsy progressed quickly. I saw her on my days off and after work most days. She lived with a roommate, Nan, in downtown. Nan was ten years older than Betsy, so roughly my age, and African American. She had been a good friend to Betsy, and she is a great person. When I didn't have RJ on the weekend, I would stay over at their place and Nan would make us breakfast. We would sit and chat and laugh. After about six months into our relationship, I was totally in love with Betsy and I believe she was with me. We clicked in every way, and we were talking about spending our lives together. One Friday night, I was

there for the weekend. I was excited to be off the full weekend and spending it alone with Betsy. We had a great dinner out and a few drinks. Betsy didn't drink, which I never thought twice about. When we got home, we headed to bed. Our relationship was still in that "could not wait to be in bed and alone together" phase.

Suddenly, while lying-in bed Betsy started to shake, and her eyes were rolling back. I was trained enough to know a seizure when I saw one. I threw on my sweats and yelled for Nan. I didn't know what was happening. "Call 911!" I yelled. Nan came in and told me she could handle it. This had happened before. I was totally in shock. What was this? After about ten minutes they both came out and Betsy was still pale and shaky a bit, but ok. I asked what just happened? Nan excused herself and I sat next to Betsy. "Are you ok? Do you want to go to the ER?" Again, I pleaded and asked her what was wrong. She said she had bone cancer and it was

terminal. She explained she had these seizures from the medications and the chemotherapy. My tears just kept flowing uncontrollably. I was speechless for the first time in my life. This person that I see as so full of life was dying. Why? We had just found each other and planning forever together. I was in shock.

Chapter 41

The temporary apartment I moved into was getting too small for RJ and I, so I seriously started looking for a house to purchase. I had been saving money as best as I could. RJ was in Catholic school and there was no help from his father with that cost. I struggled with the payments but wanted him to have the best education possible. Luckily, that year our lawsuit (from my academy class) came through and I received $25,000. You see, the city tricked us when we were in the academy. They first started by saying we had to take a $6,000 pay cut. We had no choice. One of our classmates that next year just happened to be looking at his

personal file and noticed that the city had his starting date into the academy as March 13, 1993. He brought it to their attention, but no one seemed to care. He then went home and contacted a few of us to check our files. Something was not right he said. We contacted the Fraternal Order of Police and told them that our whole class had the same start date.

The city had changed all our start dates to have it match the date the salary change went into effect. They deceived us all. We filed a class action suit, and it took four years to win and get our back pay, which was $25,000. No one from the city ever took responsibility for it.

That money came in very handy for my down payment. I found a great house on Summerdale Avenue. I was thrilled own my own home. RJ had his own bathroom connected to his bedroom and we had a great rec room downstairs with a fireplace. This part of my life seemed to

be complete. I loved being a mom, a cop, and a partner. Until….

Chapter 42

My world seemed to be turned upside down as far as Betsy was concerned. I was still in shock over what she told me. I kept asking her what I could do to help. "Do you have the best doctors? Can I go with you?" I asked. She sat me down and explained it like this. She had several back surgeries starting from when she was fourteen. She was in high school and played on the basketball team. They were playing a game inside and she was going for the ball when she flew backwards and hit the bleachers. She broke her L4 & L5 vertebra and was in a body cast for eight months in Dupont hospital in Delaware. She had several

surgeries after that, and she had screws placed in her back during one of them. It was later determined that these screws caused a certain amount of people to have cancer. Unfortunately, she was one of them. They removed the screws, but the cancer remained. This was the worst day I have had with her. I felt so helpless and knew nothing about cancer. 1997 was not exactly the information highway like it is now. No google or Facebook.

Chapter 43

I t was 1999, I had been in the crime scene unit for three years now, handling many homicides, rapes, police discharges, and high- profile jobs. Me and my partner got assigned a very high-profile homicide. It was funny because I almost went home early that night because I had a softball game. We got the call, and I went. It would turn out to be one of the city's highest profile homicides in years.

It was a serial rapist from 1997-1999 and he increased to homicide of a young women in Center City. We arrived on the scene and the street was in a very affluent area of the city. It was invaded by news trucks everywhere. Crowds of

onlookers and of course the high-ranking PPD. Inside the second-floor apartment complex, we found a beautiful young college student murdered on her bed. It was a complicated scene, so we spent hours collecting evidence, photographing, fingerprinting, and taking DNA swabs. We even tried a process of fingerprinting the victim's neck because she was strangled. It was a very emotional scene for everyone involved. Family and neighbors waited outside as we zipped her into a body bag and tried to give her some dignity in death. We carried her gently down the stairs and out to the waiting patrol wagon. Cameras were clicking and the family was crying, while the onlookers just wanted a glimpse. Our investigation showed the perpetrator climbed a tree next to the young woman's balcony on the 2nd floor and he got in. He had raped several women, but this escalated to murder. A few years later he was a match to our DNA sample in another state for

another rape. He was sentenced to life for her murder. Of course, our pictures were on the front page, "the money shot".

Chapter 44

After about a year, Betsy moved in with me and we made a comfortable home together. She wanted a pool table, so we purchased one and put it in the dining room right in front of the bay window. We had lots of gatherings and got a lot of use out of the pool table. One Halloween, when I answered the door, a little kid looked in and said to his mom, "Oh, a pool table in the dining room, we need to do that." It was adorable. I loved our home. Betsy was a good partner. She would make dinner when I got home, and we cleaned together. I am, as everyone knows, OCD and she was on board with my cleanliness. When she went to her

treatments and doctors' appointments, she insisted on going alone. She was sick a lot. It seemed like whenever we had plans or would have a weekend away, she was sick. I spent countless nights in the ER with her. She told me to go home but I would not. Most of the time she shut me out and said if she included me then it would bring it into our lives even more. I was so torn, but I tried to respect her wishes. In the meantime, my work was slipping. I was getting very emotional around dead bodies. This was my job I could not let them see me sweat, but the thoughts of her dying kept popping into my head. She kept telling me it was in remission, and then months later it would be another tumor found. I relived this year after year. At one point I bought a cemetery plot near where she grew up. We spoke about it at one point, but I did not want her to know I thought she was going to die. She would constantly lose 20 or 30 pounds in a month. She looked

very weak and tired sometimes, but then she would pop back. Months would go by, and she would play softball and carry our cooler on the beach. It was always the joke she was the strongest of us all. Each time the ups and downs, the hope and hopeless. It was excruciating not knowing what was going to happen.

Chapter 45

Some of the worst assignments in the Crime Scene Unit was suicides. Now we, as a specialized unit in Philadelphia, did not normally handle suicides. The city was divided into divisions; south, northeast, and west. These divisions had detectives and that division's detective would handle most suicides. Unless it was a police officer or a city official, then they would call us to process the scene. All too often a fellow police officer would take their own life. Unfortunately, you usually know the person or their family member. You try like heck to be unemotional and professional, but its exceedingly difficult. Most of the times they would shoot

themselves, as their service weapon is very accessible. Some gunshot scenes can be a biohazard mess. These are the ones that stay with you, and you lose sleep over. To this day I see faces in my sleep. Even the most seasoned officers lose sleep over certain homicides.

Chapter 46

Betsy was on disability and did not work due to her back issues. I was the one keeping us in tasty-kakes and meatballs. My paycheck was paying the bills and I was continuing to count on court overtime to help. One night I came home particularly tired and stressed. I had one of those suicides in which it was a cop friend that I knew. He took his own life. It was a shotgun to the head, which is the most devastating damage to the head there is. Very gruesome. I mentioned that we helped find a hotel for the wife and kids to stay in. At that point, Betsy said, "So how did you get that cleaned up?" I immediately replied, "UMM we are the

police. We don't do that." Betsy, being from the suburbs, was unfamiliar with city ways. That night she kept repeating, "I can't believe the family has to deal with the mess." It is like being traumatized twice. Then, her business mind kicked in. She had graduated college with a business degree and had a good head on her shoulders. She started to research the web and found there were no crime scene clean up businesses in the tristate area. After many months of research, this is where the idea developed.

Betsy discovered through her research there was a national organization for "crime scene cleanup." It was an association that over sees the standards for the industry called the American Biohazard Restoration Association (ABRA). The ABRA's president was Ron G. from Queens, NY. He owned a Biohazard company. Ron spoke with Betsy for about an hour and provided her with lots of information. He invited us to come to their

annual conference in Las Vegas. Betsy almost jumped out of her seat asking if we could go. She said this would give her something to focus on and not think about her cancer. How could I say no? So, I requested vacation, which was not easy since our unit was shorthanded, but I promised my Sgt. that I would work over-time when I came back. Then we booked our flight and hotel.

Chapter 47

I had been to Vegas a few times before. The first time was with Dina in 1993. I had graduated from the Police Academy and was walking the beat in the Center City district. I was home listening to the radio and a commercial came on advertising Barbara Streisand was in concert. She was touring and heading to Las Vegas on New Year's Eve. Oh my god! You see, I had been following Barbara since I was 14 and had never seen her live. What a great New Years it could be. When Dina came home, I blurted out about this and begged her to go.

She thought for a minute, as she always would, and said she would buy

the tickets to the show ($500.00 a ticket), but she asked how I was going to get off work. If you were a brand-new rookie you would be working the New Year's parade for sure. There was no way I would get off. It would be impossible. I immediately lost my will to live. I had to figure out how to ask Lt. Sidney. He was a very military kind of boss, very fair, and I think he liked me. I believe he thought I was going to be a good cop. I had to take this head on, so I went into his office the next day and rattled on about Vegas and Streisand and ticket prices. He cut me off and said enough. If you are crazy enough and gutsy enough to come in here and ask, I must approve it. I nearly hugged him. I ran to the pay phone and called Dina. I said start buying those tickets! She could not believe it. A rookie getting off on their first New Year's Eve is unheard of. We went to Vegas and although Dina was not a big fan of Streisand, she admitted she had a great time. New Year's Eve in

Vegas was the best. The streets were all closed off and you walked along with thousands of other people. After the show, Dina said, "Wow, I really enjoyed it!" I was still not making a ton of money, and although Dina paid for the tickets and airfare as my Christmas gift, spending money was on me for the week. I said to Dina, "Don't worry, I'm going to win it at the poker table." I brought $200.00 and won $1200.00 the first night! All that card playing with my brothers as a kid paid off. We would have Friday night card games as a family, along with a big pot of spaghetti and muscles. Some of the most fun nights I remember from my childhood.

Chapter 48

I have always had a good business mind. I am very organized, and details are the most important thing for me. I guess that's why I was a good crime scene investigator. In 1998, we started our business. We had spent every spare minute we could writing a business plan for the Small Business Association (SBA) for a loan. They wanted statistics, numbers, and endless information. We had business cards, brochures, and a website. We spent a full week coming up with a name that would tell the story of what we did. A name that twenty years ago, no other company used in any form. Our name was Trauma Scene Restoration, Inc. Not crime

scene clean-up. We felt it was too harsh of a name. We had a slogan that read, "We restore the scene and peace of mind" on the website and brochure. It also had a very peaceful picture of a sunset. Now everyone uses the word restoration in their name.

Chapter 49

The PPD has a policy if you have out-side employment, you needed to put in the proper paperwork. Basically, one form stating where you are working and how many hours you will be working. Sometime in early November, when we knew the starting date of the business, I submitted the proper paperwork. I really was only doing the payroll and the insur-ance scheduling for our company. I was not going to do the actual cleanup. My commanding officer was not exactly a fan of mine, and my gut feeling was that he did not like lesbians. I could never prove that, but it was a gut feeling. Anyway, the

paperwork kept being sent back to me, repeatedly.

Eventually, it became closer to the starting date, and I kept wondering where the approval for my paperwork was. Usually, these kinds of things would only take a few days. It was now going on months. January 1st came, and our website went live and the phones were on. We got our first call sometime around February 12, 1999. A cop shot his wife and then himself. She survived and he did not. It was a freezing cold snowy night and they wanted us out as soon as possible.

After the authorities were finished with their investigation, then and only then we could start the cleanup. Photos were taken before and after, of course. We received a call from the medical examiner's office because we sent our brochures to them. The family had children and needed to get back into their home. Well internal affairs were called by my Commanding Officer. He said I worked

without a signed approval. Technically that was true because he never gave it to me. However, after a long battle and grievance, I won and was able to own the company. Jealousy is a evil emotion.

Chapter 50

Our business did very well the next few months. We had a few commercial facilities to clean up. One that stands out in my memory was a paper shredding company in Philadelphia. There was a horrific accident where a worker was killed. When we arrived, OSHA was on site shutting the facility down until it was professionally mediated. The story was that this company had enormous shredding machines. They were the size of car and the blades on the machines were about 20 feet across and 20 feet high.

They would shred the paper into huge bundles about 50' x 25'. On occasion the machine would get clogged. It

was common practice for them to shut down the machine and then jump on the mound of paper to be shredded to unclog the machine. Unfortunately, when this employee jumped on the paper, he fell backwards and knocked himself unconscious. The bundle and the employee just sat there until someone, not knowing the employee was lying in the paper, turned the machine on. The shredded paper started turning red because the massive blades shredded this guy to pieces. As we assessed the situation, I assigned one of our employees to stand by the power button and not to move. Similar scenes were when we had suicides by train. That could be the worst way to die. A five-ton train demolishing your body. Always had to be mindful of that third rail.

We hired mostly cops and fireman for our business because they were accustomed to these kinds of trauma scenes. One of our best employees was my son, RJ. He got right in there and none of it

seemed to bother him. I guess the apple didn't fall far from the tree. In fact, after about six months into the business we received a call from an NYU film student, Eva. She asked if she could come visit our business. We agreed since it sounded like free advertisement. Eva went on many job sites with us, well, mostly Besty and RJ because I was still working for the Police Department. They took her to some bloody clean ups, and a few were suicides. She also did a part about Betsy and my relationship, and how I went off to fight crime not knowing if I was returning home each night. I was not going out to the actual sites. Eva decided to come to the crime scene unit and filmed a little piece there. She liked the fact that it was myself, Betsy, and my son, and oh yes, Blitz the Wonder Dog. Her film was called *Family Values* and it won the Sundance Short Festival in California.

Chapter 51

It was Christmas time and for some reason people get very depressed, so the suicide rate skyrockets. The business was terribly busy, and I was extremely busy at my CSI position. I was also doing all the Christmas shopping and decorating because Betsy seemed to be sick every other day. The worse part of shopping for Christmas was shopping for Betsy. What do you buy someone who has been dying for six years? I would try to get the best, most sentimental present ever but it never seemed like it was enough. It was emotionally destroying me. My Christmas would never be the same as before she got cancer. It was now so stressful and had become the most joyless time of the year.

Chapter 52

I n early 2000, Betsy asked if we could buy a house in Rehoboth, Delaware. The business was doing well, and money was flowing in. Rehoboth is very gay friendly. I had been going there for 30 years and moving there had always been my dream. I said sure, and the thing was, I had never turned her down for anything. We had become friends with a guy named Jim Lake. He was a contractor for us, and he and Betsy worked many jobs together. We asked him if he had ever built a house before and he said yes. He agreed to go to Delaware and build our dream house. He knew Betsy's situation, so he said he would have it done in less than six months. When the house was

being built, we would drive down every few weekends to see it. Betsy loved to get on the open road with the sports car I got her. Driving fast was her outlet she said. Luckily, I knew where the speed traps were.

In June of 2001, we had a commitment ceremony. In case something did happen to her she wanted to be "married." It wasn't legal then, but in our eyes, we were married. Also, in the eyes of the city of Philadelphia she had a partnership agreement. The wedding was held at Odette's in New hope, Pennsylvania. It was one of the quaintest towns in PA and the wedding was set on a canal with a beautiful waterfall. We had the ceremony outside with a three-piece Quartet and flowers coming across the bridge we walked down. The reception was amazing. My family, her family, and all our friends were there. My sister and her sister gave both gave a toast. Betsy's sister, Pam, directed to me that I must make sure to

always take care of her sister and to be honest with each other. That statement would stick with me for years to come. Unfortunately, Betsy's parents had to be talked into attending. When we went to them to tell them, they said, "We accept you being gay, but we just cannot accept you acting on it." So, I adopted the line when I wanted to make love and said, "Hey, do you feel like acting on it tonight?" Betsy was not amused! At the ceremony, everyone was crying through the vows we wrote, including her parents. To this day, everyone says it was the best wedding reception ever! We invited Eva, the NYU student who filmed a documentary on our company.

Chapter 53

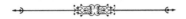

September 11, 2001, we were staying at the Days Inn for a long weekend. Our home was nearly finished, and we were so excited. We picked out furniture and carpet colors, all the best things. That Tuesday we had a meeting with the builder at 10:00 am. Betsy was in the shower, and at about 8:30 am I turned the TV on to watch the news. I was a news hound like most cops, always watching news and reading newspapers. I made it a point to always keep myself up on current affairs. I felt even though I had lacked the formal education I would have liked; I was constantly trying to learn about new topics. I was sipping my coffee that

I had gotten us from Starbucks, and I will, as most Americans will, remember this moment until the day I die. I was watching Good Morning; America and the breaking news came on. At 8:46 am flight 11 hit the north tower of the world trade center. I stood there, watching the towers on fire and I was astonished. How does a plane hit such a large visible building on a clear brilliantly bright sunny day? I yelled to Betsy about what was happening. We watched together and could not believe such an accident. Then the second plane, at 9:03 am, hit the south tower. I got chills and became scared in that moment. That day would change our lives and every other American's life forever. 2001 was supposed to be the best year, and now it was horrific. We immediately started getting phone calls and began checking on people we knew. We drove a few minutes away to the beach. I can't tell you why, we just needed to go see the beach. We sat there listening to the radio and I knew

we were at war with someone. When we saw the planes and helicopters flying over the beach, we knew the military from Dover Air Force Base was being called up. The roar of the military planes was scary. After hearing the Washington, D.C. and Pennsylvania planes crashed, I was called home by work. The police department said all hands-on deck.

Chapter 54

Betsy and I drove home in silence because we were still in shock. I reported to work at 6:00 am on Wednesday, September 12th. We were on twelve-hour shifts and no days off, indefinitely. Every state, local, and federal building needed extra security. Post offices, courts, and police stations would be good targets. The military had come into the city to protect the airports. We were doubled and tripled up in cars because we didn't have enough cars for everyone. For the first time in my 8 years of being an officer, people thanked us, paid for our meals, and handed us coffee. Kids made cards and letters and sent them to the

districts. We had lost police and fireman like never before in history, and we were all hurting. People respected us and the uniform, and I noticed that people looked to us for comfort because they feared this unknown enemy. Unlike 2020, when we were looked at as the enemy, now we were not. The police were the enemy back then, but the bombers were now the enemy.

Chapter 55

The real enemy in the past years were the criminals and murders that were shooting our children. Day after day, I had to show up to murder scenes and see black male shot in the head by another black male, or a small child shot sitting on the porch playing. Same thing every day, and we would show up to try and keep the peace and security. But the people in those neighborhoods would not help the police. "Snitches get stitches." They didn't want to get involved. It takes a toll on your psyche, and you start to take the same attitude and get the I don't care mentality. Yes, you were getting paid, but you get crapped on every day. It's

like the reasoning when you live in the ghetto, and you learn the mentality that it's not your fault that you do drugs and steal and hate the police. It's a learned way of life. That is what happens with the police when you live it day after day. It's a defense mechanism. It's PTSD but functioning through it. It's also the same as "snitches get stitches," except the thin blue line does not ask for help. Suicides were at the highest rate in the past few years, and no one still talks about it. It's an epidemic. when you have a guy who is on meth, heroine, or fentanyl and you're trying to arrest him for robbing Mrs. smith, and he resists you and you keep trying to hold him down until the Calvary gets there because he's so strong, you are fighting for your life. You don't want to hurt him; you want to arrest him. I had this experience. No matter how big or small the criminal is, if they don't want to get handcuffed it's the hardest thing in the world for not one or two, but three

cops to do. It takes you holding their legs and arms and head.

When I was a new beat cop working in Center City, I got a call for an unruly patient at the Jefferson Hand Center. I responded as well as another cop, Officer Candice Simmons. We arrived at the same time and walked in together. It was a large office part of the hospital. We approached the front desk nurse and asked what the problem was. She pointed to the back of the offices and said the older gentlemen insisted he had an appointment there and he was not a patient at that office. We slowly approached this man who was probably in his 70's. He was a frail looking man who had a cast on his arm. We asked what the problem was, and he immediately became loud and combative. After trying to convince him to leave, we decided we needed to move to the next level because he was becoming more agitated. Other patients were getting frightened. I gently put my hand on his

shoulder and said, "You must leave." He hit me in the face with his cast and I went flying across the room. It was now a fight with the three of us. We tried to cuff him, but he kept hitting us and bit my partner on the arm. We tried to call for more officers, but our radios were in a dead zone in the building. Finally, two construction workers helped hold him down and we had to hog tie him with their belts. He was 98 pounds, and it took five of us ten minutes to get him under control. He yelled that he had Aids and bit my partner. I had teeth marks in my night stick. He was on drugs and tried to cut his own arm off. Something the nurse should have told us prior to approaching him. Important information that would have helped save us a lot of time and energy.

Chapter 56

The 2001 Anthrax scare was something none of us had any experience with. We had two briefings on how to respond to these types of calls. People were panicking after New York started getting positive anthrax calls. In Philadelphia we had a whole lot of people who were on edge, from large corporations to small mom and pop stores. We had some copycat jackasses sending baking soda and flour through the mail to people. We even had a police officer bring in an envelope full of white powder, he had found in a trash can. He was immediately thrown out of the building with it. It turned out to be sugar.

In the meantime, our business was thriving. A few weeks after 911, Ron, the owner of the biohazardous company in Queens, NY, and the president of ABRA called us. We had become quite good friends with Ron and his domestic partner, Pedro. Ron was also in law enforcement. He was at the District Attorney's office in NY and we had a lot in common. I spoke to Ron when he called, and he said I got the ABC building contract. They have had an Anthrax scare and needed the building remediated. I said, "The whole building?" He said yes, and he was bringing in our company and another one from Florida. It was a huge job and we needed to combine resources. I immediately said we are in. The next few days were a blur trying to make hotel reservations, gathering people to work, and obtaining chemicals and equipment. I had to take off at least two weeks of work and now was not the best time. But I had a new Captain Snyder, and he was a great guy and really liked

me. I went to him and told him what we were doing. He was quiet for a minute and said bring me back a NYPD hat. I said of course.

Being a cop and owning the company, I always contributed to police charities, and I told all involved we needed to donate some of the profits to the 911 fund, and we all did. When we arrived at West 66th Street in New York, it was unlike any other time I had been in New York. The streets were not crowded, and the people seemed friendlier. Our company had three trucks we needed to park but the area had "No Parking" zones everywhere. We needed our supplies close by, so I found an officer and explained the situation. He said to park, and we would only get a $35 ticket. If we paid it each day, it wouldn't be a problem. The parking lots were $90 a day for each truck. It was a good tip. It took two days to set up all the equipment, including the machines for positive and negative

air flow. We had to set a clean zone and a hot zone, bring cases of water and gator aid, and buy food for all the workers. Our first area to tackle was in the mail room where it tested positive. The next area was on the next floor at ABC Studios, where Monday Night Football was filmed. It was Friday and we needed it done by Monday morning. We were told they would double our pay for those hours if we got it done by Sunday night, so we told our fifteen workers that we would double their pay from $30 to $60 an hour. We got it done. When we were in ABC studios, Peter Jennings, who was on the World News then I believe, had his dressing room there and a bathroom. When were we cleaning it, we had to make sure not to disturb his many Emmys around the bathroom? The studios were very pro-fessional, and I was so tired one night I stood behind the desk and broke out in a melody of Ethel Merman's "Everything's

Coming Up Roses." Thank God there was no Facebook, Twitter, or TikTok back then.

Later we cleaned the Manassas Courthouse in Virginia and several post offices. We worked extremely hard, made a lot of money, and everyone got a NYPD hat!

When we got a day off and made our way towards the WTC, we just could not believe the devastation and the comradery of everyone. Police departments and fire departments from all over the country were all there to help find their brothers and sisters in blue and red. It was a day I will never forget. I had tears rolling down my face, along with everyone else I was with. For the law enforcement family and fire departments across America, our hearts were broken for the loss of our brothers and sisters.

Chapter 57

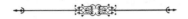

2004 was a crazy year. I was in the district next to where we lived, and I had been working there for a while. It helped a lot because I was only minutes away from Betsy if she needed me. Betsy's health over the past years had gotten worse, and she stopped going to meet clients and being on the sites when she needed to be. My son picked up the slack. He was only 19 but had a good business head on him. He knew a lot about talking to people. I started to insist on being involved with her doctors and appointments. She wouldn't always say yes, but when she would leave the house with her backpack and Walkman in hand,

I knew she was going to a treatment, and I was invited.

One night it was cold and windy out. I called her on the home phone, and she answered in her low weak voice. She would usually sound that way when she was not feeling good. She had lost a lot of weight again, like 25 lbs. and was looking very pale. When I worked night work, she would usually go to a friend's house for dinner. Either our best friends or another couple she liked a lot who had a couple of kids. They were Delia and Tracy. We played flag football together and had lots of mutual friends. As I was talking on the phone with her that night, she said she was just laying down with the dog, not feeling well. I hung up and made sure she knew I was close by if she needed me. My gut said something was not right. I drove by the house within two minutes and saw something I could not believe. Behind her car was a van, one I recognized. After I ran the tag, it came up as belonging to

our friend, Tracy. My heart just dropped. I knew this was not good. In the end, I got her to admit she was sleeping with our friend. She said she felt like she was dying and did not know why she did it. That was the beginning to a nightmare I think I still never awoke from.

As you can imagine, I was devasted. I called my best friend in Dallas who was a doctor and she got me under control. All those days and nights I had sat by Betsy's side after her treatment when she would be throwing up and I did everything a wife should. How could she betray me this way? What happened to till death do us part? We shared a house and a business and raising my son and Blitz her dog.

In hindsight, I know I should have been more suspicious, but what reason would I have to be. Ask yourself, would you ever question the person you were in love with, the person you gave your heart to, who you trusted your life with? Don't get me wrong, she was a great partner.

She would make my meals and bring me coffee on the long cold nights at work. My partner at work and her got awfully close, Mike adored her. After he got hurt, Mike would still ask about her. I didn't have the heart to tell him that we had been broken up for a long time. Years after we broke up, I still am not sure who she was and who I was in love with.

June 2004, Betsy and I went our separate ways after seven years. About a year or so before this she had been unfaithful with one of our "friends." She had explained that it was the illness and her depression that drove her to this. It took me about a week to explore my emotions and to get the anger under control to be able to speak to her rationally. She went to crash at our good friend's house. They eventually acted as our mediator to get us to reunite and for me to forgive her. I had set some ground rules that she needed to be noticeably clear and honest with me. I needed to know everything that she was dealing

with, and I needed to know where she was with the cancer treatment. The women she was unfaithful with, well, her partner was not so forgiving. She set out on a mission to figure out why Betsy would seduce her girlfriend. She said she had her doubts about Betsy but always kept it to herself, as she did not want to accuse her girlfriend and be wrong. She followed Betsy several times to the hospital and she even knew someone there. The Center City hospital was not a cancer hospital, but a pain management treatment center. Betsy was saying she was getting chemo, but she was just getting some shots for pain in her back. On the day I found out, Denise, the partner, called me and asked to meet for a drink. I was reluctant, but I thought I owed it to her. Betsy and I were back together but I was still curious about what she had to say. I was not ready for what was to come. She stumbled on her words and then just blurted it out. Betsy did not have cancer, never did. I was floored and tears just

filled my eyes. The first thing I thought was thank God she is going to be ok. But then I was overcome with tremendous anger. What I had gone through for the past six years. My day-to-day struggle to keep the faith and be strong. Driving 120 miles to pick up shark cartilage that might help her a bit. I never once would complain if I had a cold. I must give Denise credit because she got to the whole truth in the end.

It was a cold rainy Saturday afternoon, and we were home sleeping in late and I brought Betsy a cup of coffee in bed and handed it to her. I said, "Betsy, I know you do not have cancer. I know you have been lying to me." I couldn't finish my sentence without blubbering. She immediately said, "Yes, I have been lying." She didn't deny it for one minute. I must give her a lot of credit for that. She cried for a long time, uncontrollably. After taking her to see a therapist, she was diagnosed with Munchausen Syndrome. A psycholog-ical disease that goes back to childhood

trauma. I told her I would stand by her as I did every day of our lives together with the cancer. In the end, she kept lying and cheated on me again. I ended our relationship immediately when I discovered it. The relationship could not survive so much deception. She could not be forgiven. Even though I vowed till death do us part, I am glad she is alive.

Chapter 58

Blitz the Wonder Dog, our black cocker spaniel, he was the best dog ever. Betsy had gotten him while she was in college and hid him in her dorm room. I immediately fell in love with him. He would come everywhere with us. Softball games, BBQ's, house parties. Everyone loved him. On one of our group vacations, we went to Providence Town, "PT" as most of the gays call it and rented a great big house. PT was a very gay friendly town and it had gay friendly beaches. We took Blitz of course and realized that we had tickets to the Boston Red Sox game, and we were staying overnight at a Boston hotel. In 2002 the hotels were not so pet

friendly. So, my brilliant idea was to call the hotel and say I had a handicapped mother and I asked if they happened to have a direct elevator from the parking lot to the rooms. They said yes, they did. That was great because we could sneak Blitz in with no problem. Except when we got there and few of us go check it out, the elevator opened right in front of the security desk. We had to come up with a plan B. We had a large hockey equipment bag, so we decided to put Blitz in it. We zipped it up to his nose and someone carried it right past the guard. We did this a few times because he had to go potty of course. When it was time to leave, we were packing, and the bag was on the bed. Blitz jumped up in the bag, as if to say I am ready!

Chapter 59

I n 2014, a 33-year-old black male is reported missing by his sister in West Philadelphia. His car was in front of the house he rented, and his roommate was nowhere to be found either. The sister files a report, but of course, being an adult, the male was free to leave, so not much they could do. The family decided to go to the house accompanied by the police and try to get in through the rear door. They search the first floor, then the basement. The male was in basement obviously dead, shot in the head. No signs of the roommate in the basement. We arrive and start to process the scene of the basement. It's pretty much a

shithole. Newspapers, food, and clothing were everywhere. Swat had cleared the house before we entered making sure no bad guys were hiding upstairs. As we were doing our usual photography of the entire house, we get to a front bedroom and look in. We all stopped and started to back up. The entire room was covered with a white substance, I mean two feet of it. We had no idea what it was. There was also what appeared to be clothing piles throughout the room. Then we see a glimpse of a hand sticking up from a pile. We then went outside and called the hazmat team because we didn't know what the substance was. After an hour of onsite testing, they say it's lye. Garden lye will cover up the smell of decomposition. The body in the bedroom was the room-mate, also shot. An arrest was made a few weeks later. The photographs in court made the jury cringe. The defendant was found guilty as charged.

December 28, 2000, Lex Street Massacre, ten people were killed in a drug house and they were all shot execution style. It was the worst mass murder in Philadelphia's history. It took more than three days to process the scene. It was very gruesome. I was not personally on this scene, but my co-workers were. Lex Street was a weeklong crime scene and very stressful on everyone involved. If you think you have a tough job when your printer runs out of ink or your computer stops running, imagine you are eating lunch and get this call as an officer. You are sipping a coffee one minute and the next you are standing in a pool of blood with someone's brains blown away. I have always said police work is 90% boredom and 10% crazy.

In 2010, I was assigned to a scene in the heart of a south Philadelphia neighborhood that was mostly Italian. The scene was a white female shot in the face. It was a possible suicide, but it was

suspicious. Our team arrived, and I am the assistant. Let me explain how the system works. In the crime scene unit, it's broken into three squads; 1,2, and 3. 3 squad was midnight to 8:00 am, which was my squad. There were 6 people to a squad, and usually only four officers were working because two people would have their days off. We would have a "wheel" so to speak and whoever had the least number of homicides or police shootings, etc., would be the assigned lead investigator. Their partner would be the assistant, responsible for documentation of the scene and sketching the scene. That was especially important for court presentations. People would always ask me how long it took to process a scene. A scene could be a stabbing death with just blood and a knife, and that would be one hour perhaps. Shootings with 50 shots and five guns, could take eight hours. I always said, "Eeewww, that looks like it hurt." just to lighten the mood. Everything at the scene

must be photographed, measured, DNA swabbed, and sketched, and collected. When scenes were huge and it was 15 degrees out and snowing, you somehow get the scenes done in record time, especially when your pen and camera stop working because it's so cold out and you stop feeling your fingers and toes.

This scene in south Philadelphia was at a beautiful rehabilitation house. It looked like something out of a magazine. Apparently, the husband of the dead women was a contractor, as most Italians in south Philadelphia were. Everyone was doing their part in the house. The homicide detectives were trying to find the victim's car outside and had a few sets of keys with remotes on them. In meantime, I am doing my sketch of the house. I was at the stairs as they go to the second floor. I am leaning my foot on the bottom step and drawing, when suddenly the stairs start to rise open like in the TV show *The Munster's*. They opened with a

hydraulic system. I jumped back thinking somebody was hiding in there and we all drew our guns. Low and behold it's drugs and money stashed away. Everyone was asking me what I did to open the stairs. I was like, "Hell if I know!" Just then, the homicide detective walks in from outside and we realize it was the remote. It was not for the car but rigged for the stairs. Unbelievable!

Chapter 60

There are always those scenes that involve celebrities and everybody on duty in CSU wants to be a part of it. There was a Philadelphia Phillies baseball team player and his wife who had their home in another state broken into and they needed an elimination DNA sample. We had to go to the ballpark to swab the player and his wife. One of the things stolen was his World Series ring, and fortunately it was recovered. There were also a few Philadelphia Eagles players who spent their off time in a gentlemen's club and apparently were accused of inappropriate behavior. We had to process them and report. Over my career I

have had many "confidential" cases, but I always knew the news would eventually get the story.

I had only been on the force for about three years when we were chosen for the 1996 Summer Olympic security team. This was a great honor and several female officers that I was friendly with, including my domestic partner at the time, Dina, were going. We all got accepted and passed the intense background check. We all put our memos into the police department because most the departments were giving the officers administrative leave since it was an honor to be representing our city. No one refused but we each had to use our own vacation time and sign a waiver. They wouldn't even sponsor us for transportation. We all went on our own time and our own dime. What an experience it was! It was the middle of July in Atlanta, and it was extremely hot, about 96 degrees and that was early morning. The Olympic village would raise flags

warning about the heat danger. Black was the worst and by 10:00 am every morning the black flag was raised. Most of us were able to stay in the dorms at the University of Georgia. It was a beautiful college and it had two Olympic size swimming pools that we could use. Anyone that knows me knows I cannot swim, so on those hot days with my noodle in hand, I went into the pool, and so did the Swedish swim team. They were extremely helpful to me. There were so many cops from every country. I especially liked the female cops from Norway, and they knew how to sew. Our uniforms had long khaki pants and for a few dollars, they cut and hemmed everyone's pants into shorts. It was a two-day waiting list and well worth it. We met some great people and made some lifelong friends. The Olympics had some awesome sponsors, including Swatch Watch, Nike, and Budweiser. We received a gift every night from each of the sponsors, including a six pack of beer

each night. We were assigned to different venues each day. Some were good and some were like the Equestrian, which was a bit boring. The women's softball team was a popular one, as well as the basketball Dream Team. Centennial Park was beautiful. There were vendors and food and this great fountain made from the Olympic rings. It was a great place to meet people. There was no charge to get in and not much security, not like now where there are check points and bag searches. We were there eighteen days, and on the second to last day, July 27th, it was almost midnight inside the Centennial Park. It had been a long hot day and we were back in our room enjoying the air conditioning. The mood changed quickly as people started banging on all our doors doing a head check and asking everyone to report to the security post. We were not armed because we weren't allowed to be, but we all ran as cops do. It was a bombing and people were injured. This

was unreal. A bomb in the park I loved so much. Later the next day, the details came out of a woman dying and lots of people hurt. I believe this changed the way we looked at any large gathering for a long time. It changed the mood for us all, of course. We were cops and every one of us took it personal.

Chapter 61

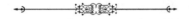

Early on in my career, I was working patrol. I really liked working the street. Working 601 wagon with Lisa every day, we always had something interesting. We were young rookies and full of as they say, piss and vinegar. The radio dispatcher will relay what they call flash information. This usually is an exceedingly small amount of information that they have so far. It usually includes the sex of the doer, race, height and weight, and what they are wearing. Then they say NFI. That means no further information. We hear the police radio put out a call for a robbery in progress, a female robbed and beat.

Directions were given to head west on Market Street. So, the cars and wagon proceed west on Market Street. We went the opposite way in case he changed direction. We see a male fitting the description coming towards us walking swiftly. We gently pulled up to him and since it was a gun point robbery, we drew our weapons and said, "Show us your hands!" He was cooperative but a bit hostile. He said what I have heard hundreds of times, "You are stopping me because I am black," and I responded, "Why yes, yes I am." He was totally shocked! I explained there was just a robbery, we were investigating it and he matched the description. If it were a white male, who did it, we would be stopping a white man. The victim was driven to our location, and the man we stopped wasn't the robber. We thanked him and he said, "You almost had me with what you said, but I understand it."

To me, some of the most dangerous assignments in the crime scene unit are

the ones inside the prison. We had to investigate any suicides or homicides that occurred in prison because they are in the confines of the city of Philadelphia. The scenes are usually a simple 8 x 8 cell. Perhaps a bed sheet or shirt that someone hung themselves with. The problem is all our weapons are taken and put in a lock box. A flashlight and a fingerprint brush are not much protection. Luckily, I always had Lamar in my squad, and he is 6'8" and 340 lbs. When I stood behind him you couldn't see me. Many times, it was sad because you had a guy with minor charges who couldn't make bail and he would be scared to death. He couldn't take it so he hung himself. Whereas the repeat offenders, they looked at it as three h and a cot.

Chapter 62

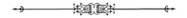

Sex crimes a/k/a Special Victim's Unit has a branch who specifically deal with child abuse. Mostly parents or relatives. A good friend of mine is a detective in the child abuse unit. Most of the time they process their own scenes, but this case was something she needed our help with. It was a three-month-old baby girl. It was a Hispanic family from east division. The baby was in Children's Hospital ICU on life support and pretty much brain dead. Someone had either shaken her or slammed her head on something. The detective noticed two important things, the baby's little legs were very pale and had what appeared to be hand marks,

and there was a slight bruise on her forehead. Detective Dankworth knew I had talked about a process I used with photography and ultraviolet lights. The baby's skin was so transparent that the bruises would probably appear with this process. I collected my equipment and hurried to the hospital. When I arrived in ICU, only the mother and grandmother were there. No dad? I set my camera and equipment up and I turned the lights off. It was unbelievable! Both of her legs had full finger impressions like she was grabbed by the legs and picked up by them. Next, the forehead area. Wow, the round bruise came up bright and purple. Someone had picked this baby up and slammed her head on something. These are the hardest cases. Innocent kids who cannot protect themselves or don't have anyone to protect them from the monsters they live with. I believe the dad was convicted of this crime. Unlike other jobs, as a law enforcement officer you must wear

so many different hats, cop, therapist, teacher, etc., and then go home and hug your kid and kiss your wife or husband and try to not think about it. Try not to let the anger or the sadness spill over into your personal life.

Chapter 63

June 2004, Betsy and I went our separate ways after seven years. About a year or so before this she had been unfaithful with one of our "friends." She had explained that it was the illness and her depression that drove her to this. It took me about a week to explore my emotions and to get the anger under control to be able to speak to her rationally. She went to crash at our good friend's house. They eventually acted as our mediator to get us to reunite and for me to forgive her. I had set some ground rules that she needed to be noticeably clear and honest with me. I needed to know everything that she was dealing with, and

I needed to know where she was with the cancer treatment. The women she was unfaithful with, well, her partner was not so forgiving. She set out on a mission to figure out why Betsy would seduce her girlfriend. She said she had her doubts about Betsy but always kept it to herself, as she did not want to accuse her girl-friend and be wrong. She followed Betsy several times to the hospital and she even knew someone there. The Center City hospital was not a cancer hospital, but a pain management treatment center. Betsy was saying she was getting chemo but she was just getting some shots for pain in her back. On the day I found out, Denise, the partner, called me and asked to meet for a drink. I was reluctant, but I thought I owed it to her. Betsy and I were back together but I was still curious about what she had to say. I was not ready for what was to come. She stum-bled on her words and then just blurted it out. Betsy did not have cancer, never

did. I was floored and tears just filled my eyes. The first thing I thought was thank God she is going to be ok. But then I was overcome with tremendous anger. What I had gone through for the past six years. My day-to-day struggle to keep the faith and be strong. Driving 120 miles to pick up shark cartilage that might help her a bit. I never once would complain if I had a cold. I must give Denise credit because she got to the whole truth in the end.

It was a cold rainy Saturday afternoon, and we were home sleeping in late and I brought Betsy a cup of coffee in bed and handed it to her. I said, "Betsy, I know you do not have cancer. I know you have been lying to me." I couldn't finish my sentence without blubbering. She immediately said, "Yes, I have been lying." She didn't deny it for one minute. I must give her a lot of credit for that. She cried for a long time, uncontrollably. After taking her to see a therapist, she was diagnosed with Munchausen Syndrome. A psychological

disease that goes back to childhood trauma. I told her I would stand by her as I did every day of our lives together with the cancer. In the end, she kept lying and cheated on me again. I ended our relationship immediately when I discovered it. The relationship could not survive so much deception. She could not be forgiven. Even though I vowed till death do us part, I am glad she is alive.

When the incident with George Floyd happened and I saw the video, I immediately cringed. Myself and all the good cops in America cringed with me, because good cops hate nothing more than bad cops. As I have been saying "you had us at hello" BUT then the riots and looting and the killing of innocent officers and now we have all taken the defensive. Is Floyd completely innocent? Who knows, but he was wrongly killed. The Black Lives Movement was wrong also. No one in any neighborhood wants their stores destroyed and cars burned.

Many people have judged the police without knowing what it is like to have to make a life and death decision in a split second. You sit at a diner and take 10 minutes to decide on lunch. Yet as a police officer, you must size up someone and decide if the person with his or her handle in their waste band will pull a gun and blow your head off, or if he's going for a cell phone. No amount of training in the world prepares you for that split second decision. Those who commit the most crimes on their own people are the same people protesting the police. Killing women and children night after night. Not caring when they spray the street with an AK47 if the six-year-old on the porch making smores with his mother gets shot in the head. But no protest over this? We as law enforcement, are trained to react professionally, we are trained not to be emotional, yet how do you do that when a three-month-old baby girl's head is smashed in and beaten by the baby's

daddy. Are we made of Teflon, where nothing sticks in our guts? Suicides, alcoholism, and divorce are the highest rates in police officers. Only since 2008 did the Philadelphia Police offer any type of psychological professional help to its officers. That was because 7 officers were killed, and we were all traumatized. Sleepless nights and horrible nightmares, ulcers, and physical exhaustion. Just another part of the job they say. This is what you signed up for they say.

We sacrifice school trips and plays, baseball games and Christmas mornings, our baby's first words, vacations that are planned, and days off cancelled. We sacrifice by seeing our friends and partners gunned down and people cheering that a cop got shot.

Chapter 64

In 2015, my partner, Jody, and I were headed with one of the Assistant District Attorneys to do a walk through on a crime scene we were to testify about on the upcoming days. It wasn't unusual for us to do this because it gives the ADA a good insight of the scene. It was early morning around 8:00 am in the west Philadelphia area of the city. We were driving down Lansdowne Avenue and we made a quick turn on a small east-west street when we see thick black smoke pouring out of a row home in the middle of the block. We immediately informed police radio and jumped out. we observed two houses partially engulphed in flames.

One house had a handicap ramp and we were informed that the other had several small children that lived there. I took the house with the children and Jody ran into the handicap ramp house. I yelled out police department and several children were already safe in the rear yard. We got them out front and then I ran next door to help Jody. There was a man with no legs in a wheelchair and flames coming from behind him in the kitchen. He said, "Don't let me die, please help!" We had to carry him and his wheelchair out of the house to the ramp. Rescue made—no injuries, and the ADA stood outside in amazement.

Afterwards she wrote a letter to the police commissioner and the district attorney praising our swift action in unpredictable circumstances. Making quick decisions and working as a team. That is what we were trained to do. Then, after it's over, you realize you could have been killed. Even more important, we

didn't see a "black" man with no legs, we saw a man with no legs and saved his life. We both got the Fraternal Order of Police award for Officer of the Year.

Chapter 65

The art of removing and transporting dead bodies takes practice and good cologne. Working the EPW (emergency patrol wagon), you can go weeks without getting called to take a 5292 (dead body), or you can get a streak when you get one, two, or three a day. The most difficult part of the job for rookies is their first 5292. Especially one that has been decomposing for a while. The smell can traumatize you for weeks and can stay in your nose and mouth. When I first came on the job the old timers would say to use Vick's vapor rub, but I found that Vicks does the opposite and opens your nasal passages. I started using my favorite cologne and sprayed it

in my mask. It worked wonders. The worst 5292's were the 3rd floor apartments on the hottest days in August, and the guy happens to weigh 300 lbs. Sometimes, believe it or not, you have the family and neighbors hovering over you just get the money out of his pocket before he goes to the morgue and put into evidence. Sometimes you must remove bodies from crawl spaces and roofs, and wrapped up in trash bags or carpets. Trunks of cars in the dead heat of summer is the worse. You can see the body fluids leaking under the trunk and you hesitate to open the trunk because you know what it is going to look like. Your self-defense mode kicks in and your sense of empathy starts to diminish little by little.

Once you get to the morgue you had better have a body ticket with you. As a copy you just want to drop the person off and get the hell out of there as quick as possible. Sometimes you are so busy, especially in the summer, you may be

there for hours waiting. The first time I was there, I started smelling what I thought was spareribs. Then I go into the office, and indeed they were eating spareribs for lunch. I felt my breakfast that I had hours before coming up my throat. My thoughts are the dead ones never complained and we always tried to be as respectful as possible. If you don't develop a thick shell, you will not make it in this job. Going home and wanting to fall into the arms of the person you love, male or female, black or white, but your shell has gotten so thick that it will not break. No one can understand. Not your kids, not your spouse, not your friends, not anyone. Therefore, we as police usually only associate with other cops. The funny stories about police work is how we "let it out" but safely in a joking manner to the men and women who do the job. This is when the thin blue line is formed and not broken.

Chapter 66

In 1990, being gay was still a sensitive subject. It's funny that anyone that was gay knew who else was also gay. We had no protection in our jobs as I found out firsthand in the courts. My ex-husband was terribly upset and angry when I left him and eventually told him I was gay. Leaving him and being with ML, I am sure stung his manhood. Leaving for another man was one thing, but for another woman somehow was like an attack on his manhood. In no way do I feel that way, it's just the way I am made up I believe. Loving who I feel comfortable with. No other reason. I suppose I was ahead of the "coming out times" telling him and

being honest when I did. Most gay people were still hidden way in the closet at that time. But I needed to be honest with him and my family and frankly, myself. After our divorce was final and I was living with ML, I was extremely happy and felt at peace. Unfortunately, being able to spend time with my son was hard, I worked shift work and was trying to provide a good life for my son. I insisted on sending him to private school because Philadelphia's public school system was terrible. So, I sent him to catholic school. My ex-husband refused to help pay for it. His reason was because he paid $45 a week for child support. That was all he was responsible for. In fact, there was a time when RJ asked him for a new pair of sneakers when he was with him for the weekend. RJ came home and said "Oh, dad said I only needed new shoelaces." I bought him his sneakers the next week. I was watching Cagney and Lacey one evening while doing the ironing and I heard a

knock on the door. A gentleman handed me an envelope and said you have been served. It was a notice to appear in court. I was being sued for full custody of RJ. My ex-husband alleged I was unfit due to my lifestyle (being gay). I was floored. With everything that happened I always thought my ex-husband knew I was a good mother. That I would die for RJ and sacrifice anything for him. I called my best friend, Lorie, the doctor, and said, "What do I do?" She was always my voice of reasoning, my go-to person. After my hysterical crying for ten minutes, she said, "OK let us get down to business, you need a lawyer." I knew I had to fight this. I was making some money, but now I had to come up with a retainer fee for a lawyer.

Someone recommended a lawyer through our union, which they would help pay. He wasn't the best, but it was what I could afford. I got together school records, medical records, dentist and childcare certificates. My lawyer said I only needed one

witness, so I chose Donna, my neurosurgeon friend. She testified about seeing the interactions between my son and myself, and how I had family support and a job and friends. After all that, the question that the Judge had was, is Donna gay? She tried to be evasive and stunned by the blatant question by a man who was supposed to stand for justice and be non-bias, to be able to decipher lawful vs. prejudice. No one should ever have their child taken away because of who you choose to love. But with a stroke of the pen, the Judge did just that. The Judge's last words were, "Oh by the way doctor, how is the Temple University neighborhood? My daughter will be attending, and I want to know if it is safe." She shook her head and walked off the stand. Being a doctor at Temple, Donna has seen the worst of the worst, but this was the most egregious she had ever seen. My son cried that day to stay with me and I felt helpless for the first time in my life. I had only weekend visits for about a year. I

out of the darkness

eventually went back to court with a new lawyer and got a different Judge. The custody was reversed. That was justice. My struggle to become a police officer was a career that I knew I needed to accomplish. Anyone that knows me is aware of my biggest fault. When I set my mind on something, I do not stop until I get it.

Hard work and determination have always been who I am. My police work would make a small difference in the justice system. Ironically, a big part of my job in the crime scene unit was to appear in court. Testifying intimidated some cops, but not me because the truth and evidence was always on my side. I always said, "It didn't happen if you can't prove it," and in court you must prove it. I sleep well at night knowing how many child killers, murderers, and rapists I helped put in jail by doing my job well. Domestic violence victims should not be held to the promise of "Till death do us part" by their significant other.

Chapter 67

One of the strangest things that happened to me was when I was assigned to the northeast 2nd district. I had a break from the Crime Scene Unit for a year or two and was in patrol. One of my half-brothers happened to be in the same district. I never met him until I was assigned to this district. I knew he was a cop, so when we met, we just acknowledged each other and kept it professional. Not many people knew we were half-sister and brother. When my father died, I was working the district. My brother called me and told me. I drove to the district and said my father died and I was going to take my four days I got for

funeral leave. But I was not going to be at the funeral. My father never gave me anything when he was alive. I was taking those days for myself. I called Betsy and told her to make a reservation in Atlantic City because I had four days off. It was funny because my half-brother came in at the same time and told my supervisor his dad died. Then they knew and just shook their heads that we had kept that a secret.

About six months later, I was working on a beautiful Sunday morning, sitting in my parked patrol car, drinking my coffee. Sunday mornings were usually slow and quiet until everyone sobers up from Saturday night. I was surprised when the police radio went off, "Beeeep." Shots fired. Off duty officer calling it in. Woman shot in basement. The address was right up the street where I was parked. I respond, "212 car I am around the corner." I did not recognize the address at all. As you drive to these calls a million scenarios go through your mind. You have the most

minimal information at this point. Not knowing if the shooter is still on site, if it's self-inflicted, or a family member, but we knew an officer called it in off duty.

I was the first on the scene, so I let radio know and they advised to be careful. My heart was racing, but I ran in and I got into the house. The radio says the person is in the basement, so I go towards the basement door with my gun out, and as I investigate the living room looking for any clues, I see a cabinet with an American flag in a rectangle box like when you die in the military. Then I see a man's picture next to it. To my astonishment, it's a picture of my father. I am so confused. I run down to the basement and a female is lying on the floor bleeding from the face with a rifle next to her. I lean down to check her pulse and push the rifle away from her for my safety. She is alive. I get ready to go over radio for an ambulance, still confused about whose house I was in. Just then, someone grabs the back

of my shirt from behind. I got ready to swing at them, but it was the wagon crew, my friends, Len and James, #201 wagon. He says, "Get out of here DJ." I am still baffled. I asked, "Why? Whose house is this?" He says, "Carl's mothers. She shot herself over your father's death. He called it in after being on the phone with her. You do not want to be first on this scene." They were watching out for me. Truth is stranger than fiction. I called my brother and said, "Hey, good news, I finally found out where dad lived, bad news, the wife shot herself." She lived after being in the hospital for a long time and died a few years later. Probably the same as my mother, of a broken heart.

Chapter 68

I was on patrol in my rookie days in the 6th district. This district was in the heart of Philadelphia's Center City area. Mostly businesses, restaurants, bars, and banks with some expensive homes and condos. Daywork tour was 7:00 am to 3:00 pm, so getting calls right at 9:00 am for a robbery alarm from a bank was not unusual. The employees would open and trip the alarm at times. One of the first things that the instructors drill into your head is, "Do not get complacent." Sgt. Adams, the drill instructor, would repeat this day in and day out. I would dream of that phrase! He would say you could get the same false alarm nine days in a

row and the tenth day it could be the real deal and you may get shot because you were complacent. On this morning, robbery alarm at a bank on my sector. I was telling myself all the way there, don't be complacent Donna. I arrive before my backup and head into the bank cautiously, gun in hand. I was immediately met by the bank manager, and I asked for his ID. The alarm was tripped. In the 1990's, we didn't have handheld radios yet, so I was making my way to the car to go over radio and resume my back up and say false alarm. I leaned into the car, and I was about to grab the radio microphone and I felt someone come up behind me. Before I could turn, the guy pinches my ass. WTH! I grab him and whack him with my slap jack. As we struggle, here comes the cavalry. My back up arrived because I didn't have a chance to call in the false alarm. They think I'm struggling with a bank robbery suspect, so they help me get him under control. He went to the

hospital and then to Special Victims Unit with a host of charges, including assault on police. I had to explain how he was not a bank robber, but a pervert and he grabbed my ass. The result was many days of everyone chuckling during roll call. You never know what you are going to get out on the street of Philadelphia. You must laugh at times; this was one of those times.

Chapter 69

Late summer 2010

Midnight to 8:00 am was always busy in the Crime Scene Unit. Roxborough is a part of Philadelphia. Pretty much the furthest west of the city. It's very suburban and it's where most police and firemen live. It's a low crime area with nice homes. I was the assigned on a homicide of a 20-year-old white male who was hosting a party with about fifteen friends. A group of uninvited males tried to crash the party and were thrown out of the house. One male doesn't take no for an answer. He pulls out a gun and shoots the host. Kills him

instantly and takes off. So senseless and tragic. No one can predict these things, and they happen all the time in the city. But I digress, we got to the scene and go into the house where we were met by the first officer on the scene. Usually, the first officer on the scene has the crime scene log, which has everyone who goes into the crime scene. This ensures the integrity of the scene. The officer gives us a quick synopsis of the scene. He also says, "Well, there's good news and bad news. The good news is we captured the Boa snake and its back in its cage, BUT the tarantula is still loose. I immediately say, "Tell me again what a tarantula is?" "A large black hairy spider" he says. Me and my partner look at each other and cringe. Ok, need to get to work, scene is in living room with three shots fired and a few bullet holes in the wall.

We immediately find two of the shell casings and begin searching for the other one. One of the officers suggested one

of the witnesses said someone threw something in the trash can. I went into the kitchen and there is a paper towel on the top of the trash. I pull it out and the biggest, scariest, blackest spider is sitting under that paper towel. I scream like a girl and knock the trash can over. My partner, Lamar, comes running in and throws a Tupperware bowl over it. Lamar always had my back. He is 6'6" and 325 pounds of pure heart. He's the kindest, funniest person I know. We laughed all the way back to the unit.

Chapter 70

Thinking back to my first few years in patrol, I really loved the interaction with the community. Working the 6th District, I dealt with a variety of people. It had residential upper class million-dollar homes at one end of the district, and the other end Richard Aleen Projects. There was a business district and of course the historic district, where the liberty bell was and the Constitution Center. There were thousands of tourists a day. One daywork tour, myself and my partner for that day, Collen, answered a disturbance business call. These were usually someone who wasn't happy about the refund policy or the service they received.

Not this call! We were called to a doctor's office at Jefferson Hospital. As we entered the offices the nurse at the front desk directs us to the rear waiting area. As we approach the rear, we hear a male yelling that he has an appointment. It was a small frail looking older gentleman in his 70's with a cast on his arm. Since this place was called the hand and arm center, we thought he fit in. We proceed to ask him what the problem was. He again yells that he has an appointment. The doctor finally comes out and says he is not a patient there, but he does have an appointment in New Jersey. My partner tries to reason with him, but he doesn't want to hear what we have to say. So, here's the tough part of being a cop. We had about ten people scared in the waiting room and the doctors and nurses wanted this guy gone. He was not being cooperative at all. Ask yourself as you are reading this, what if you were a cop, what would you do next? If you do nothing you look like

an idiot in front of these people. But if you take the step you are trained to, you could be accused of excessive force. Stop and think. No, there is no time you must decide NOW. So, we did what we were trained to do. After asking several times for him to leave, I placed my hand on his arm gently and said, "Come on sir, let's go outside." WHAM! I got struck in the chest with his cast. I went flying across the room. Now everyone scattered and it was on. Me and my partner tried to subdue him and handcuff him. No go, he had a full cast on his one arm. We got one cuff on him, then he bites my partner on the arm and was yelling he has AIDS. I grabbed my nightstick and tried to fend off the bites, then he bit my stick. We called for help on the radio to assist officer. We had a few contractors next door who came running in and we used their belts to hog tie the guy. My Lt. finally got there, and we must 302 him (police jargon for commit him.) So, our Lt. asked the doctor, "Does he

have Aids? He bit our officer." After some encouragement, the doctor looks him up and says, "No, he doesn't. He is a mental patient and tried to saw his own arm off." You think maybe that was something we should have been told prior to coming in the door? Police know very little about what they are walking into with a thirty second radio dispatch. If they are one of the good dispatchers they will try and give you updates as you proceed to the location. The most dangerous jobs in law enforcement are the unknown.

Chapter 71

Going back to my patrol years. 1993-1996 were some fun times being a tight nit squad as we were. We could depend on each other and felt confident that we had each other's back. Lisa, Tommy, Ed, and so many others. This one night we were out to dinner, and you must understand cops eat at only certain places. There are two reasons for this. One, they feel safe that the establishment likes cops and won't spit or put something in their food. Two, when you eat a meal at a sit-down restaurant people either want to ask you "police questions" like, "Officer, what should I do, my neighbor's dog is always barking?" or they don't like you

and give you the stink eye, like you're not supposed to be eating. That said, we went to dinner at this small Italian place in Northern Liberties. They had great food and a small dining room. As myself and my partner, Lisa, and our supervisor and his driver sat and ate, we laughed and were having a good time. I was eating a salad and just put a wedge of tomatoes in my mouth when my Lieutenant made a joke. Well, I laughed and wham! That tomato wedge went down my throat and since it was still a little frozen, it cut off my air way. I was choking and doing the universal sign with my hand on my throat. My partner at first thought I was joking around and then I started to turn all shades of red and blue. She screamed, "She is choking!" The whole place was full of cops in uniform. I had my trauma plate in my ballistic vest. My boss tried the Heimlich, but nothing happened because my trauma plate, smack in the middle of my chest, was preventing it. Just then, my

partner Lisa whacked me in the back and the tomato came flying out like a missile. It was very scary and all I could think was, "Damn, a tomato was going to take me out." The next day the sign in the roll call room read "Killer Tomato" and "Attack of the Killer Tomatoes." It was an experience I will never forget and I owe my life to my colleagues.

Chapter 72

I had a great career and have been blessed with no serious injuries on the job. Today I am retired and I'm living at the beach part time and enjoying myself. Being a police officer, no matter if you are in a large city of 2 million people or a small town of 2,000 people, is a tough job but it is very rewarding. Crime Scene Unit was my calling and seeing such devastation day in and day out was not easy. The end of the life of any human being is tough. No matter if it's a person who sold a gun to someone and that person killed someone or someone who leaves a gun laying around for a child to shoot themselves. The goal should be to bring the

person to justice. Justice must be swift and harsh to stop the crime. I consider myself a survivor of this special career. When you have a job where the moto of your unit is "When your day ends ours begins" it's special. God bless my brothers and sisters in blue. To all we have lost to violence and didn't get to go home to your family. You are the true hero's.